LINKA NEUMANN

WILDERNESS KNITS

SCANDI-STYLE SWEATERS FOR ADVENTURING OUTDOORS

PAVILION

First published in the United Kingdom in 2021 by
Pavilion
43 Great Ormond Street
London
WC1N 3HZ

ISBN 978-1-911663-83-6

A CIP catalogue record for this book is available from the
British Library.
10 9 8 7 6 5 4 3 2 1

Design: Kitty Ensby
Photography:
@stineogjarlen / Stine Mette Fjerdingstad og Halvdan Jarl
Laugerud
@valleyknits / Linka Neumann side pp. 4, 8, 10, 24, 47, 100,
103, 114, 115, 126, 127, 144
Aslaug Håvardsrud p. 27
Bodil Gilje p. 46
Mathias Rose p. 102
Models: Stine Mette Fjerdingstad, Halvdan Jarl Laugerud,
Caroline Marie Rosenberg, Line Victoria Sverdrup, Ivar
Lien, Luise Engesvik

Printed and bound by 1010 Printing International Ltd., China
www.pavilionbooks.com

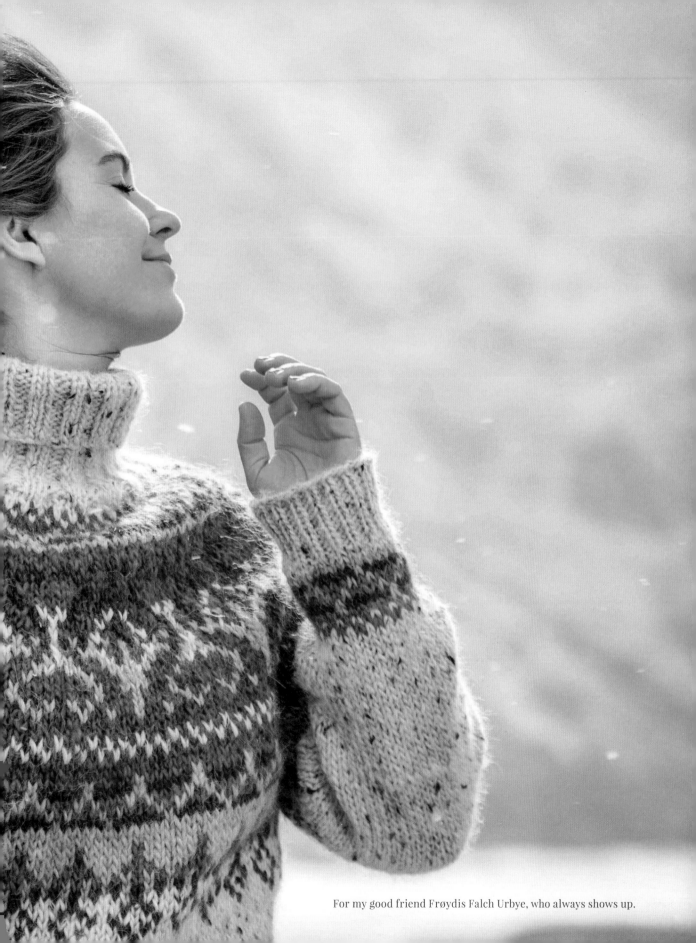

For my good friend Frøydis Falch Urbye, who always shows up.

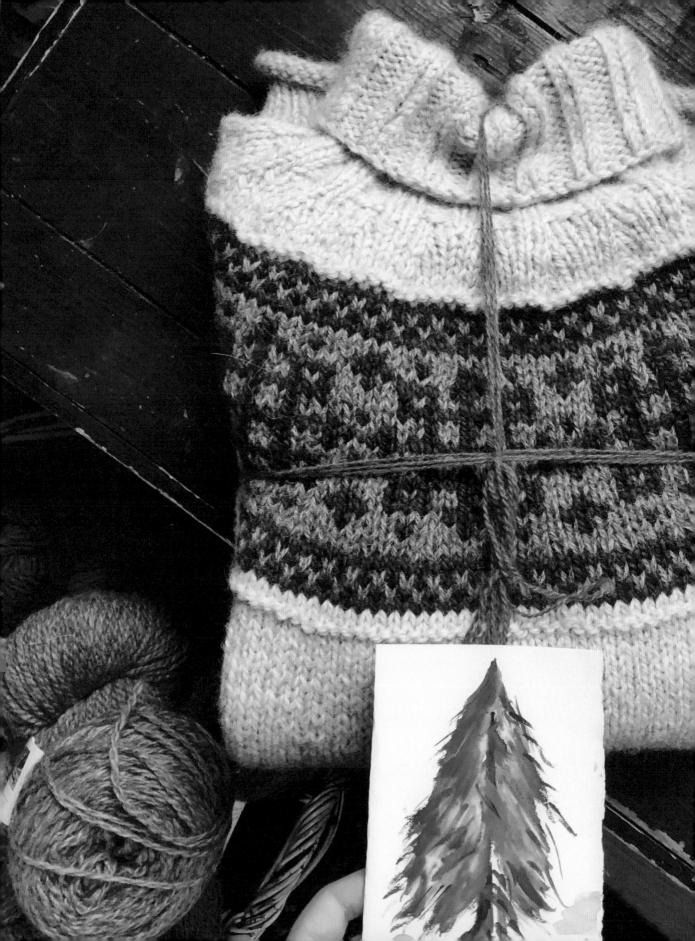

Contents

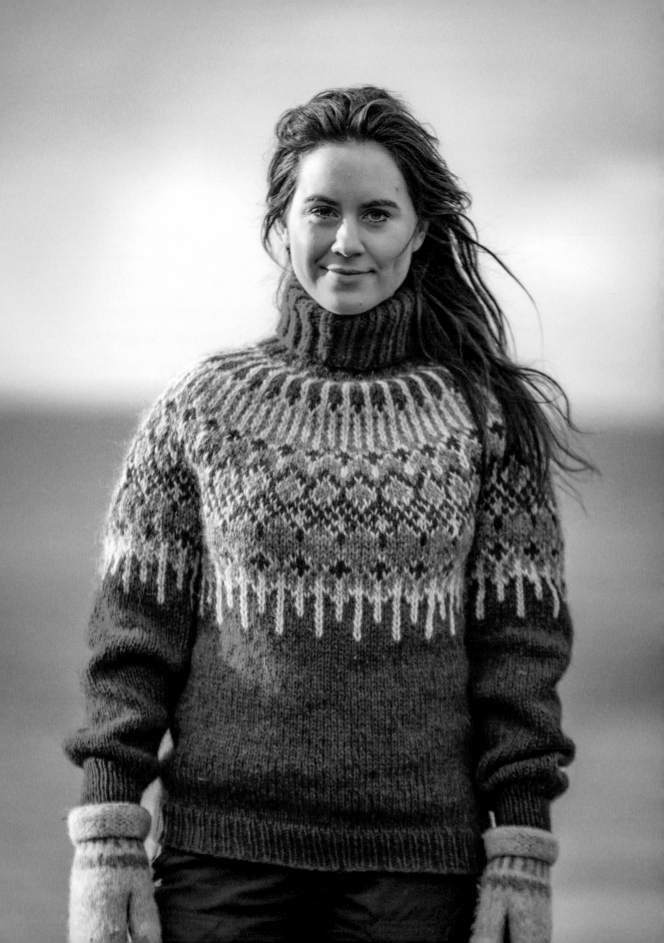

Introduction

Four years ago, my two dogs and I moved to Røros to hunt for new adventures. I had no idea how this choice was going to change my life. At the nursing home where I worked, absolutely everyone knitted – both patients and staff. Except for a scarf I knitted as a child, I had no real experience, but when I saw their beautiful knitwear, I felt motivated to knit. I decided to create a traditional Marius sweater, and that is how my passion for knitting and needlework began.

Ever since I got my first Husky as a child, dogs and the outdoors have been a big part of my life. I grew up not far from the home of the famous adventurer and dog sled driver, Helge Ingstad. When I was not at school, I spent most of my time there, learning about dog sledding and experiencing what the Norwegian forest has to offer.

Today, the wilderness and the animals living in it are my greatest sources of inspiration. Nature and animals take my breath away every single day, and therefore it is natural that the garments I design can be used outside in the Norwegian weather!

The Wilderness Sweater was the very first jumper I ever designed, so it feels a little strange that it might end up being the most popular. Every time I see someone knitting my garments I feel an enormous sense of pride and it makes me feel all warm inside!

People who spend lots of time outdoors need durable, quality garments, and quality is something I am very passionate about. When I become really interested in something, I get completely captivated and, therefore, I have spent a lot of time testing different yarn qualities. The yarns used in this book are from Norwegian and Icelandic sheep. These are durable, robust yarns that withstand harsh winters and fresh summers.

After knitting for two years, I wanted to share pictures of what I was doing, and I started the Instagram profile @valleyknits, which opened up many opportunities for me. In August 2018, a publisher contacted me about publishing a book. Of course I said yes, even though I thought it was scary to collaborate with someone about what until then had only been "mine". It quickly turned out that their confidence gave me a little push and more self-confidence – and soon the creativity was unleashed

There is a lot of work behind every single design, and countless hours of knitting and pondering over colour combinations and choice of yarn. And not least, quite a few stitches have been unravelled along the way.

I am proud to share my designs with you and I hope you like the garments and get inspired to knit.

Thank you very much!

Linlea

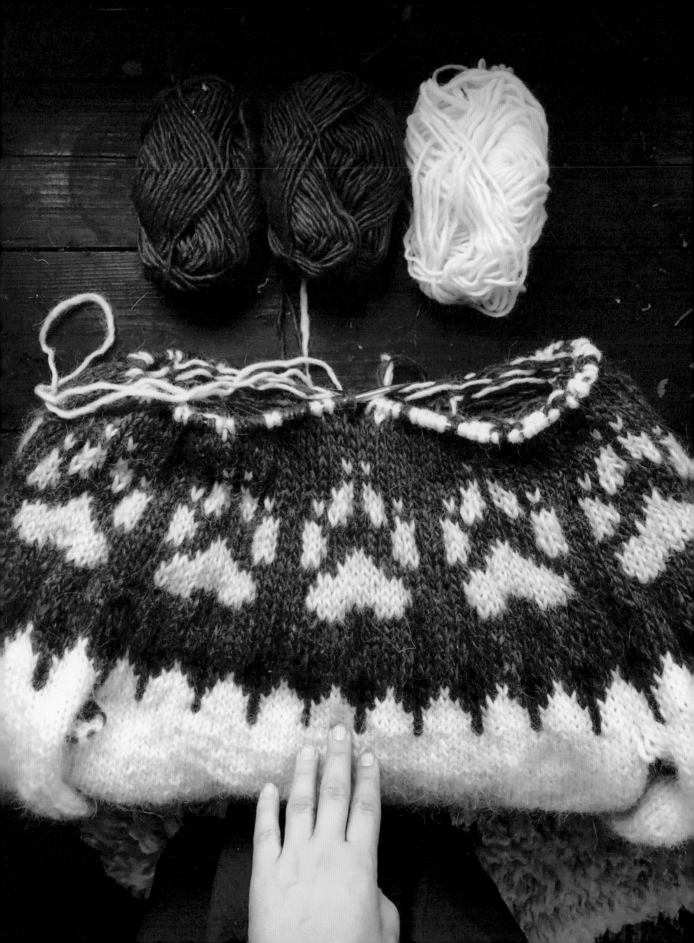

About the yarn

The garments I knit have to withstand rough weather, therefore I only use robust, durable and untreated wool from Norwegian and Icelandic sheep.

The Icelandic yarns, Álafosslopi and Léttlopi, contain both top and undercoat wool, which are water-repellent and incredibly warm. The other yarns I have used in this book are from Norwegian sheep. Most Norwegian yarns contain only undercoat wool and consist of long, durable fibres that can withstand a lot of use.

I especially love pelt yarn from Hillesvåg Ullvarefabrikk. All the colours in the pelt yarn series (Blåne, Tinde, and Sølje) are dyed on the sheep's natural grey colour, which gives a mottled appearance and an incredibly nice shine, and feels very soft.

The Norwegian yarns used in this book are:

3-ply Strikkegarn from Rauma (10cm [4in] = 22 sts)

Vamsegarn from Rauma (10cm [4in] = 14–16 sts)

Finull from Rauma (10cm [4in] = 26 sts)

Peer Gynt from Sandnes Yarn (10cm [4in] = 22 sts)

Pelt yarn from Hillesvåg Ullvarefabrikk, available in three thicknesses:

Blåne (10cm [4in] = 14 sts), Tinde (10cm [4in] = 22 sts) and Sølje (10cm [4in] = 25 sts)

Troll from Hillesvåg Ullvarefabrikk (10cm [4in] = 13 sts)

The Icelandic yarns used in this book are:

Álafosslopi (10cm [4in] = 13 sts)

Léttlopi (10cm [4in] = 18 sts) If you knit with two strands of Léttlopi held together, it is a similar weight to Álafosslopi. Good to know if you find a colour in Léttlopi that does not exist in Álafosslopi.

For sensitive skin:

I know some people think wool itches. Wool always becomes softer after washing and usage, so my advice is to rinse the garment before use (just remember to dry it flat so that it does not stretch). Among the Norwegian yarn types I use in the book, pelt wool is the softest and the least itchy.

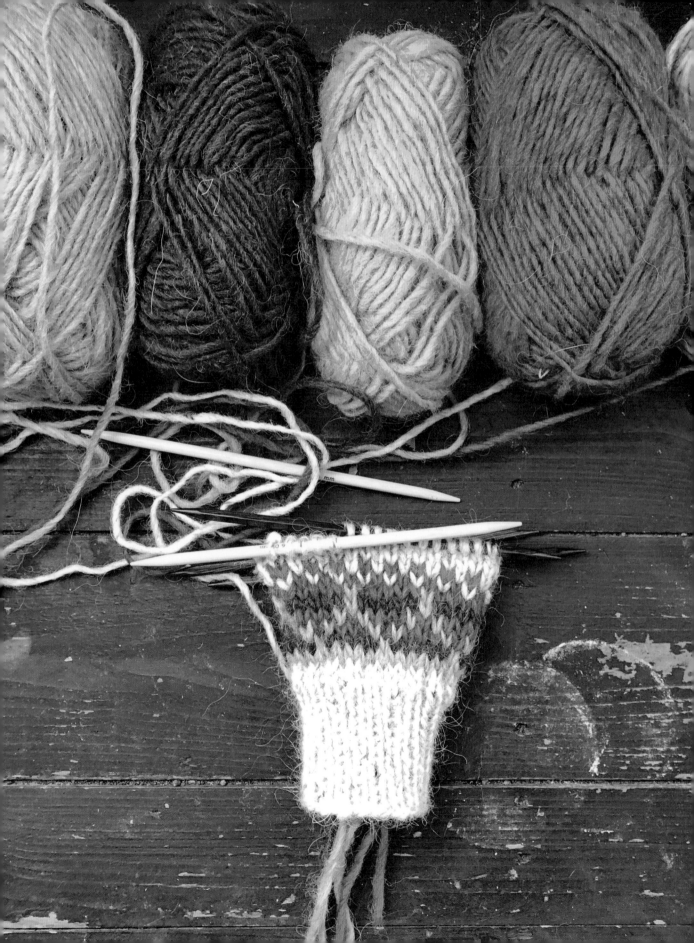

Before you begin

- Search the garment's hashtags on Instagram – this will give you various ideas for choice of yarn and colours.

- Search online for the many great instructional videos that explain different techniques and skills.

Measurements

When taking measures: make sure you do not pull the measuring tape too tight.
Chest measurement: measure on the widest part of the chest.
Sleeve length: measure from underarm to the point where you want the sleeve to reach on the wrist.
Full length: measure from the shoulder down to the end of the sweater.

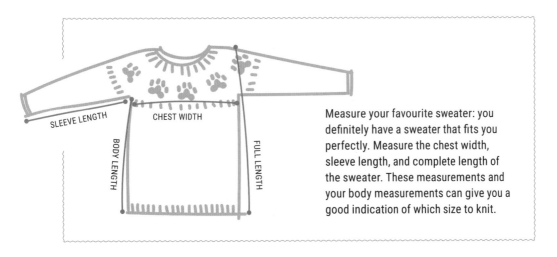

SLEEVE LENGTH CHEST WIDTH BODY LENGTH FULL LENGTH

Measure your favourite sweater: you definitely have a sweater that fits you perfectly. Measure the chest width, sleeve length, and complete length of the sweater. These measurements and your body measurements can give you a good indication of which size to knit.

Tension (Gauge)
Always check the tension by knitting a tension square. Count the number of stitches per 10cm (4in), change to thicker needles if you have more stitches than stated. Switch to thinner needles if you have fewer stitches.

Good to have
Suitable knitting needles, knitting needle gauge, measuring tape, markers, darning needle, and scissors are useful tools you should always have on hand when knitting.

Tips
If you knit tightly you may want to increase the needle size when knitting the charts.

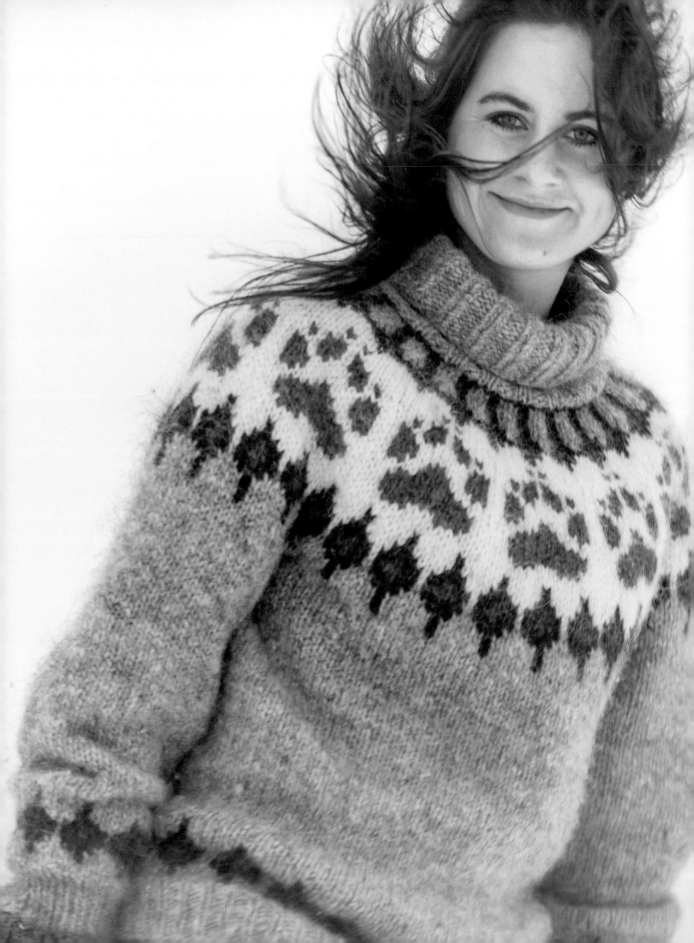

Wilderness Sweater

The inspiration for this sweater comes, of course, from my immense love for dogs. Dogs have been a big part of my life since I was little, especially Huskies. Today I have two slightly strange but lovable dogs. A sweater with a paw print was therefore something I not only wanted, but had to have.

The Icelandic Álafosslopi yarn, which is used in this sweater, consists of both top and undercoat wool. When it rains and snows, the top wool rises almost like a halo around the sweater, hence it is ideal for use in all kinds of weather.

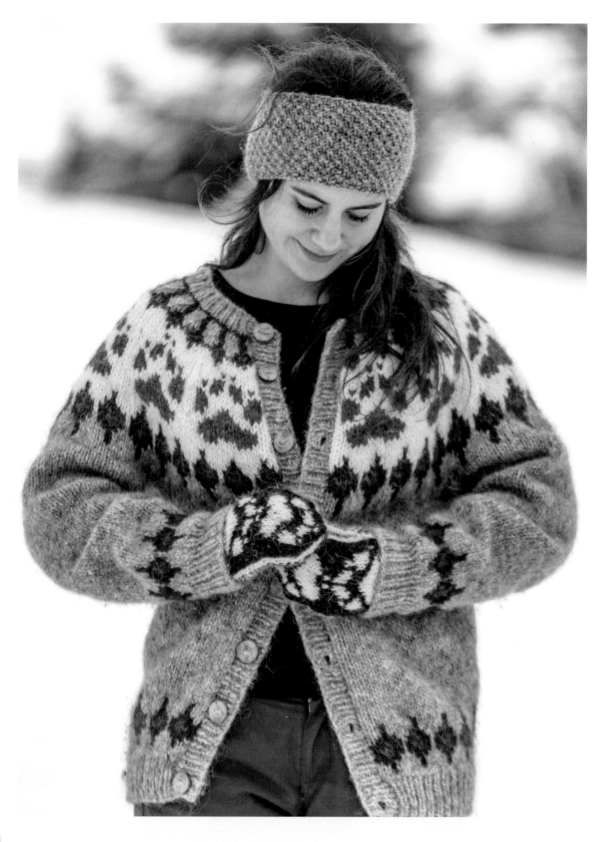

Wilderness Sweater

SIZES
S(M:L:XL:XXL)

TENSION (GAUGE)
10cm (4in) on 6mm (US 10) needles = 13 sts

YARN
Álafosslopi

AMOUNT OF YARN
Low neck:
Ash Heather (800056): 500(500:600:700:700)g
(17½ [17½:21¼:24½:24½]oz)
Burnt Orange (801236): 100g (3½oz)
Chocolate Heather (800867): 100g (3½oz)
White (800051): 100(100:100:200:200)g
(3½[3½:3½:7:7]oz)

High neck:
100g (3½oz) extra in the base colour

KNITTING NEEDLES
4.5mm & 6mm (US 7 & 10) double-pointed needles
4.5mm & 6mm (US 7 & 10) 40cm (16in) circular
needles
4.5mm & 6mm (US 7 & 10) 80cm (30in) circular
needles

MEASUREMENTS
Sleeves women: 47(48:49:50:51)cm
(18½[19:19¼:19¾:20]in)
Sleeves men: 50(51:52:53:54)cm
(19¾[20:20½:21:21¼]in)
Chest (unisex): 93(101:110:120:129)cm
(36½[39¾:43¼:47¼:50¾]in)
Body length women: 41(42:43:44:45)cm
(16¼[16½:17:17¼:17¾]in)
Body length men: 43(44:45:46:47)cm
(17[17¼:17¾:18¼:18½]in)

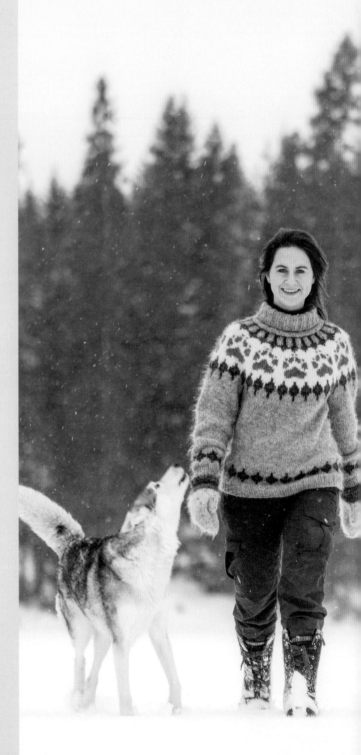

BODY

With 4.5mm (US 7) needle and Ash Heather, cast on 120(132:144:156:168) sts and work k1, p1 rib for 7cm (2¾in). Change to 6mm (US 10) circular needle (cont in st st in the round) and place a marker at beginning of the round. Work Chart A (if you knit tightly, go up one needle size when working charts). Cont in Ash Heather until the body measures 41(42:43:44:45)cm (16¼[16½:17:17¼:17¾]in) for women and 43(44:45:46:47)cm (17[17¼:17¾:18¼:18½]in) for men. Insert a marker after 60(66:72:78:84) sts so you now have a marker in each side (= front and back piece). Place 7(9:10:11:12) sts from each side on scrap yarn or a stitch holder. Set the work aside and knit Sleeves.

SLEEVES

Using 4.5mm (US 7) double-pointed needles and Ash Heather, cast on 34(36:38:42:42) sts and work k1, p1 rib for 7cm (2¾in). Change to 6mm (US 10) double-pointed needles (cont in st st) and inc 2(6:4:6:6) sts evenly on first round = 36(42:42:48:48) sts. Work Chart A (change needle size if necessary) then cont in Ash Heather. Place a marker around the middle st under the sleeve and inc 1 st on each side of the marked st every 8 rounds until there are 52(54:56:60:62) sts. Work until the sleeve measures 47(48:49:50:51)cm (18½[19:19¼:19¾:20]in) for women and 50(51:52:53:54)cm (19¾[20:20½:21:21¼]in) for men. Place 6(9:10:10:11) sts from the middle of the sleeve on scrap yarn or a stitch holder. Work the other sleeve the same way.

YOKE

Knit the Sleeves onto same needle as the Body. Place a marker at the first join, to mark the beginning and end of the round. You should now have 198(204:216:234:246) sts on the needle. Knit Chart B for the yoke (change needle size if necessary) and dec as shown in the chart.

Tip

To prevent the strands on the inside of the sweater from becoming too long (behind the paws), you may want to twist the yarn regularly while knitting.

Low neck

Work to the round specified in the chart. Change to 4.5mm (US 7) needle and with Chocolate Heather, work k1, p1 rib for 3cm (1¼in) and cast (bind) off loosely in rib.

High neck

Work to the round specified in the chart. After inc the number of sts as shown in the chart, change to 4.5mm (US 7) needles and work k2, p2 rib until the neck measures 20cm (8in), or desired length. Cast (bind) off loosely.

ASSEMBLY

Weave in loose ends and knit (or sew) together underneath the Sleeves. Place the sweater in a bucket of water (max. 30°C [86°F]) and leave it there until all the air is out of the sweater. Dry flat and stretch into shape. It is very important that you do not hang the sweater to dry, as this will make it stretch.

Chart A

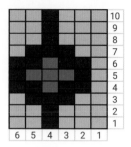

VV = Knit 2 stitches together (k2tog)
V = 1 stitch
M = stitch

Chart B

43	Inc 6(4:2:0:0) sts for high neck = 72(76:80:84:84) sts		
42	Finish chart here if you are making low neck		
41	Skip this round for sizes S, M, L		
40	Skip this round for sizes S, M, L		
39	Dec as shown = 66(72:78:84:84) sts		
38	Skip this round for sizes S, M		
37			
36	Dec as shown = 88(96:104:112:112) sts		
35			
34			
33	Dec as shown = 110(120:130:140:140) sts		
32			
31			
30			

6 5 4 3 2 1

4 = Centre front. Count from the middle of the front where to begin knitting on the chart.

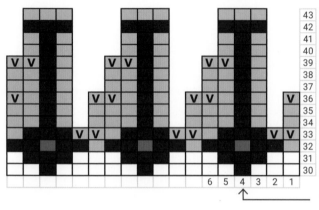

29	Dec 1 st for sizes XL, XXL = 168 sts. Skip this round for sizes S, M, L		
28	Inc 2(1:0:0:0) sts = 132(144:156:169:169) sts		
27			
26			
25			
24	Dec as shown = 130(143:156:169:169) sts		
23			
22			
21			
20			
19			
18			
17			
16			
15			
14			
13			
12	Dec 38(28:24:26:38) sts evenly = 160(176:192:208:208) sts		
11			

16 15 14 13 12 11 10 9 8 7 6 5 4 3 2 1

9= Centre front. Count from the middle of the front where to begin knitting on the chart.

10	
9	
8	
7	
6	
5	
4	
3	
2	
1	198(204:216:234:246) sts

6 5 4 3 2 1

4= Centre front. Count from the middle of the front where to begin knitting on the chart.

18

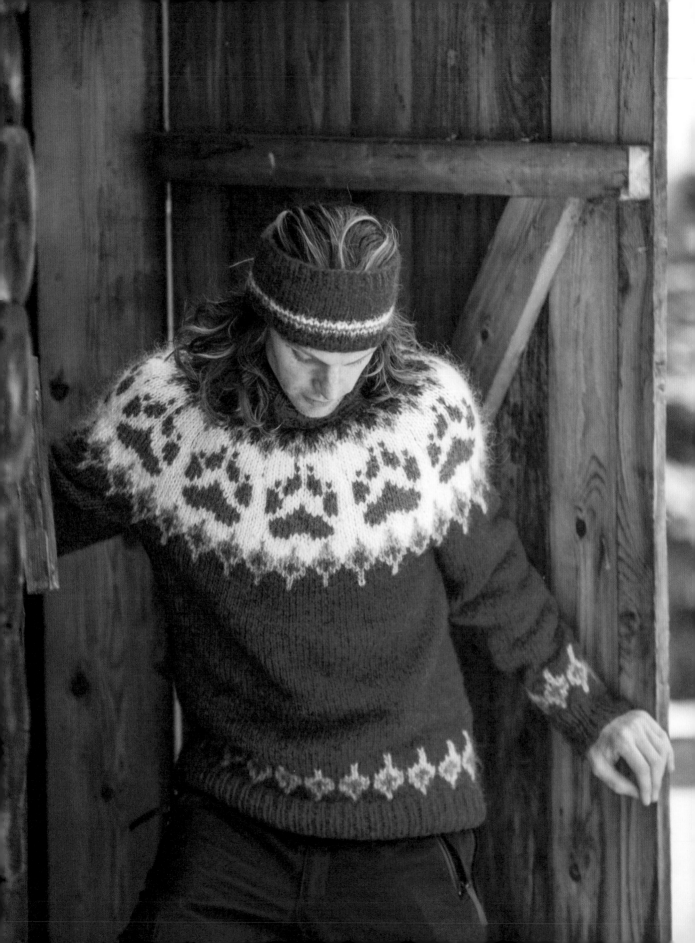

Wilderness Cardigan

SIZES
S(M:L:XL:XXL)

TENSION (GAUGE)
10cm (4in) on 6mm (US 10) needles = 13 sts

YARN
Álafosslopi

AMOUNT OF YARN
Ash Heather (800056): 600(600:700:800:800)g
(21¼[21¼:24½:28¼:28¼]oz)
Burnt Orange (801236): 100g (3½oz)
Chocolate Heather (800867): 100g (3½oz)
White (800051): 100(100:100:200:200)g
(3½[3½:3½:7:7]oz)

BUTTONS
7(7:8:8:8) 25mm (1in) wooden buttons

KNITTING NEEDLES
4.5mm & 6mm (US 7 & 10) double-pointed needles
4.5mm & 6mm (US 7 & 10) 40cm (16in) circular
needles
4.5mm & 6mm (US 7 & 10) 80cm (30in) circular
needles

MEASUREMENTS
Sleeves women: 47(48:49:50:51)cm
(18½[19:19¼:19¾:20]in)
Sleeves men: 50(51:52:53:54)cm
(19¾[20:20½:21:21¼]in)
Chest (unisex): 97(105:114:124:134)cm
(38¼[41¼:45:48¾:52¾]in)
Body length women: 41(42:43:44:45)cm
(16¼[16½:17:17¼:17¾]in)
Body length men: 43(44:45:46:47)cm
(17[17¼:17¾:18¼:18½]in)

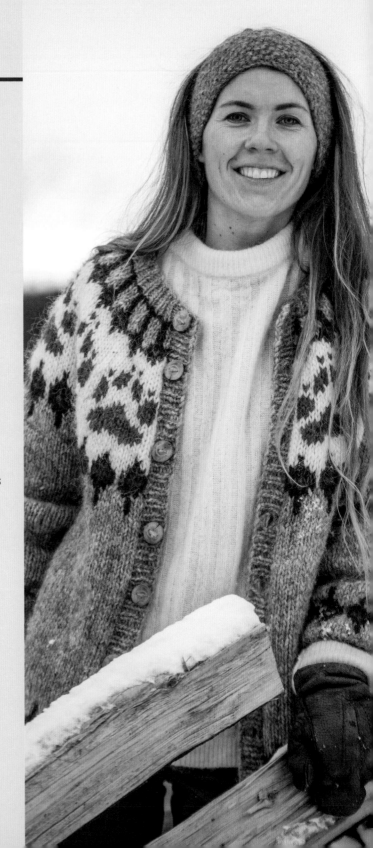

BODY

With 4.5mm (US 7) needle and Ash Heather, cast on 121(133:145:157:169) sts and work k1, p1 rib for 7cm (2¾in). The first row is the wrong side, so purl the first st (it is important that the outer sts are knit for picking up Button Bands later).

Cast on 5 sts on the right needle for steek stitches. These need to be constantly worked in purl (they are not included in the stitch count). Change to 6mm (US 10) circular needle and cont in st st in the round. Work Chart A (if you knit tightly: go up one needle size when working charts). The pattern is worked over 6 sts as shown in the chart + 1 st so that the pattern is symmetrical on both sides of the Button Bands (this also applies to the Yoke). Cont in Ash Heather until the body measures 41(42:43:44:45)cm (16¼[16½:17:17¼:17¾]in) for women and 43(44:45:46:47)cm (17[17¼:17¾:18¼:18½]in) for men (or desired length). Place markers in each side so there are 30(33:36:39:42) sts for each front piece and 61(67:73:79:85) sts for the back piece.

Place 7(9:10:11:12) sts from each side on scrap yarn or a stitch holder.

SLEEVES

With 4.5mm (US 7) double-pointed needles and Ash Heather, cast on 34(36:38:42:42) sts and work k1, p1 rib for 7cm (2¾in). Change to 6mm (US 10) double-pointed needles (from here work in st st) and inc 2(6:4:6:6) sts evenly on the first round = 36(42:42:48:48) sts. Work Chart A (change needle size if necessary) and cont in Ash Heather. Place a marker around the middle st under the sleeve and inc 1 st on each side of the marked st every 8 rounds until there are 52(54:56:60:62) sts. Work until the sleeve measures 47(48:49:50:51)cm (18½[19:19¼:19¾:20]in) for women and 50(51:52:53:54)cm (19¾[20:20½:21:21¼]in) for men. Place 6(9:10:10:11) sts from the middle of the sleeve on scrap yarn or a stitch holder. Knit the other sleeve the same way.

YOKE

Knit the Sleeves onto same needle as the Body = 199(205:217:235:247) sts. Work Chart B (change needle size if necessary) and dec as shown in chart.

The steek stitches are not included in the chart and must be worked in purl at all times.

Tip

To prevent the strands on the inside of the cardigan from becoming too long (behind the paws and the steek stiches), you may want to twist the yarn regularly while knitting.

NECK

Cast (bind) off the steek stitches and change to 4.5mm (US 7) needle. With Ash Heather, work k1, p1 rib back and forth for 3cm (1¼in) and cast (bind) off in rib.

Chart A

VV = Knit 2 stitches together (k2tog)
V = 1 stitch
M = stitch

Chart B

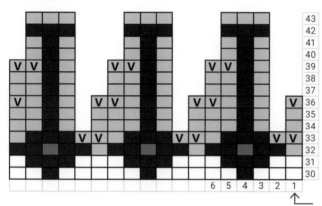

Row	Instruction
43	Work Neck after this round
42	
41	Skip this round for sizes S, M, L
40	Skip this round for sizes S, M, L
39	Dec as shown = 67(73:79:85:85) sts
38	Skip this round for size S(M)
37	
36	Dec as shown = 89(97:105:113:113) sts
35	Skip this round for sizes S, M
34	
33	Dec as shown = 111(121:131:141:141) sts
32	
31	
30	

↑ Begin here

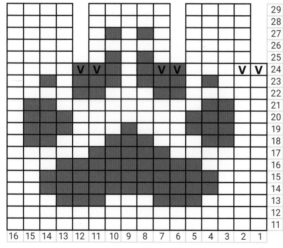

Row	Instruction
29	Dec 1 st for sizes XL, XXL = 169 sts. Skip this round for sizes S, M, L
28	Inc 2(1:0:0:0) sts
27	
26	
25	
24	Dec as shown = 131(144:157:170:170) sts
23	
22	
21	
20	
19	
18	
17	
16	
15	
14	
13	
12	Dec 38(28:24:26:38) sts evenly = 161(177:193:209:209) sts
11	

↑ Begin here

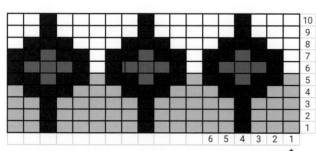

Row	Instruction
10	
9	
8	
7	
6	
5	
4	
3	
2	
1	199(205:217:235:247) sts

↑ Begin here

ASSEMBLY

Weave in loose ends and knit (or sew) together underneath the sleeves. Sew two machine seams along the edges of the steek stitches. Sew three times to make sure the seams hold and nothing unravels. Cut between the two seams and work Button Bands.

Right Button Band

With 4.5mm (US 7) needle and Ash Heather, pick up sts along right front piece. *Pick up 3 sts, skip 1 st,* rep from * to * to end. The number of sts must be divisible by 2 + 1 so that both the first and last are knit sts. Work k1, p1 rib for 4cm (1½in). Cast (bind) off in rib.

Left Button Band

Work as the Right Button Band, but with 7(7:8:8:8) buttonholes evenly spaced after 2cm (¾in). Place the lowest buttonhole approximately 2cm (¾in) from the bottom edge and the top approximately 1cm (½in) from the top edge. Cont for 2cm (¾in) and cast (bind) off in rib.

Buttonholes

Knit 2 sts together and yarn over. If you prefer, you can cast (bind) off one st, then cast on again on the next row.

Facing

Pick up sts on the wrong side of the Button Bands (the first sts in the first row). Work 2cm (¾in) st st back and forth and sew the facing over the raw edge. An alternative is to sew a ribbon over the raw edge.

Place the cardigan in a bucket of water (max. 30°C [86°F]) and leave it there until all the air is out of the cardigan. Dry flat and stretch into shape. It is very important that you do not hang the cardigan to dry, as this will make it stretch.

Kids Wilderness Sweater

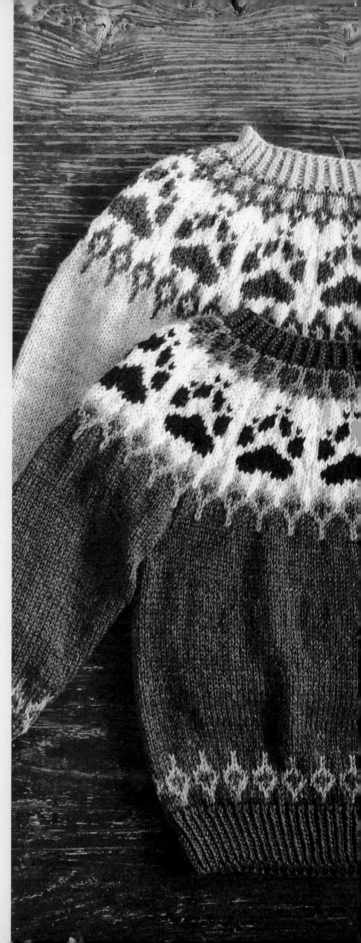

SIZES
1(2:4:6:8:10) years

TENSION (GAUGE)
10cm (4in) on 3.5mm (US 4) needles = 22 sts

YARN
Peer Gynt from Sandnes Yarn

AMOUNT OF YARN
Dark Green Melange (9572):
250(250:250:300:300:350)g
(8¾[8¾:8¾:10½:10½:12¼]oz)
White (1002): 50g (1¾oz)
Brown (3571): 50g (1¾oz)
Moss Green (9844): 50g (1¾oz)
or
Light Heather Grey (1032):
250(250:250:300:300:350)g
(8¾[8¾:8¾:10½:10½:12¼]oz)
White (1001): 50g (1¾oz)
Dark Blue (6572): 50g (1¾oz)
Petroleum (7572): 50g (1¾oz)

KNITTING NEEDLES
3mm & 3.5mm (US 2/3 & 4) double-pointed needles
3mm & 3.5mm (US 2/3 & 4) 40cm (16in) circular
needles
3mm & 3.5mm (US 2/3 & 4) 80cm (30in) circular
needles

MEASUREMENTS
Sleeves: 18(25:27:29:32:36)cm
(7[9¾:10¾:11½:12½:14¼]in)
Chest: 60(65:71:76:81:86)cm
(23½[25½:28:30:32:33¾]in)
Complete length: 35(39:42:46:49:52)cm
(13¾[15¼:16½:18¼:19¼:20½]in)

BODY

With 3mm (US 2/3) needle and base colour, cast on 132(144:156:168:180:192) sts and work k1, p1 rib for 4(4:5:5:5:6)cm (1½[1½:2:2:2:2¼]in). Change to 3.5mm (US 4) circular needle (cont in st st in the round). Place a marker at beginning of round. Work Chart A (if you knit tightly: go up one needle size when working charts). Cont in base colour until the body measures 20(24:27:28:31:34)cm (8[9½:10¾:11:12¼:13½]in).
Place a marker after 66(72:78:85:90:96) sts so that you now have a marker on each side (= front and back piece). Place 9 sts from each side on scrap yarn or a stitch holder.
Set the work aside and knit Sleeves.

SLEEVES

Using 3mm (US 2/3) double-pointed needles and base colour, cast on 34(40:40:40:46:46) sts and work k1, p1 rib for 4(4:5:5:5:6)cm (1½[1½:2:2:2:2¼]in). Change to 3.5mm (US 4) double-pointed needles (cont in st st) and inc 8 sts evenly = 42(48:48:48:54:54) sts. Work Chart A (change needle size if necessary) and cont in base colour. Place a marker around the middle st under the sleeve and inc 1 st on each side of the marked st every 1.5(1.5:1.5:2:2:2)cm (½[½:½:¾:¾:¾]in) until there are 60(64:68:72:76:80) sts. Work until the sleeve measures 18(25:27:29:32:36)cm (7[9¾:10¾:11½:12½:14¼]in). Place 9 sts in the middle of the sleeve on scrap yarn or a stitch holder.
Knit one more sleeve in the same way.

Tip

To prevent the strands on the inside of the sweater from becoming too long (behind the paws), you may want to twist the yarn regularly while knitting.

YOKE

Knit the Sleeves onto same needle as the Body. Place a marker at the first join to mark the beginning and end of the round. You should now have 216(236:256:276:296:316) sts on the needle. Work Chart B for the yoke (change needle size if necessary) and dec as shown in the chart.

NECK

Change to 3mm (US 2/3) needle and using base colour, work k1, p1 rib for 3cm (1¼in) and cast (bind) off loosely in rib.

ASSEMBLY

Weave in loose ends and knit (or sew) together underneath the Sleeves. Place the sweater in a bucket of water (max. 30°C [86°F]) and leave it there until all the air is out of the sweater. Dry flat and stretch into shape. It is very important that you do not hang the sweater to dry, as this will make it stretch.

Chart A

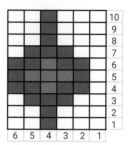

VV = **Knit 2 stitches together (k2tog)**
V = **1 stitch**
M = **stitch**

Chart B

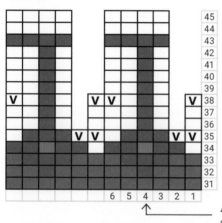

Row	Instruction
45	Change to 3mm (US 2/3) needle, dec 12(18:20:26:40:44) sts = 80(86:92:94:96:100) sts
44	
43	
42	Skip this round for sizes 1, 2, 4, 6, 8 years
41	Skip this round for sizes 1, 2, 4, 6, 8 years
40	Skip this round for sizes 1, 2, 4, 6 years
39	Skip this round for sizes 1, 2, 4 years
38	Dec as shown = 92(104:112:120:136:144) sts
37	
36	
35	Dec as shown = 115(130:140:150:170:180) sts
34	
33	
32	
31	Dec 5(0:1:2:4:5) sts evenly = 138(156:168:180:204:216) sts

4 = Centre front. Count from the middle of the front where begin knitting on the chart.

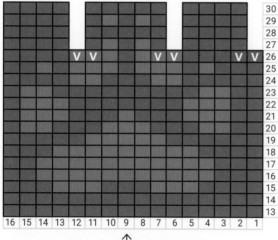

Row	Instruction
30	Skip this round for sizes 1, 2, 4 years
29	
28	
27	
26	Dec as shown = 143(156:169:182:209:221) sts
25	
24	
23	
22	
21	
20	
19	
18	
17	
16	
15	
14	Dec 40(42:44:46:32:46) sts evenly = 176(192:208:224:256:272) sts
13	Skip this round for sizes 1, 2, 4 years

9 = Centre front. Count from the middle of the front where begin knitting on the chart.

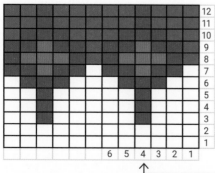

Row	Instruction
12	
11	
10	
9	
8	
7	
6	
5	
4	
3	Skip this round for size 1 years
2	Skip this round for sizes 1, 2, 4 years
1	Adjust the total number of stiches to 216(234:252:270:288:318) sts

4 = Centre front. Count from the middle of the front where begin knitting on the chart.

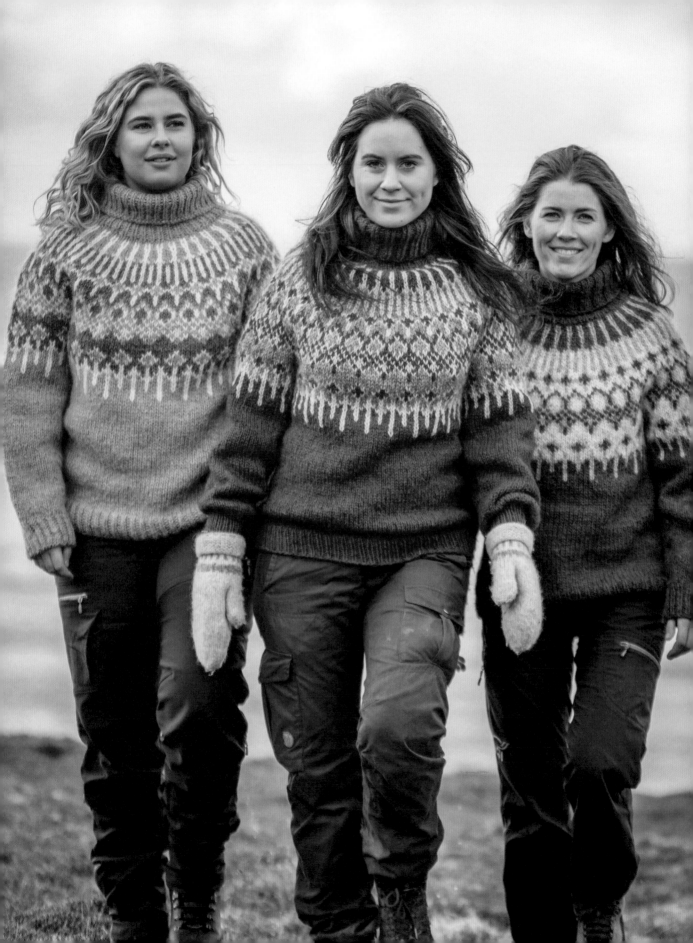

Føyka

Once, during the process of writing this book, my creativity
stopped and I felt uninspired and empty of ideas. When I informed
my editor, she suggested I design a sweater and name it after her
English Setter named Føyka. Føyka in Norwegian means 'snow
blizzard' and this became the starting point of this sweater. I
began knitting and immediately felt the inspiration coming back.
I am eternally grateful for that obstacle, without it this sweater
would not have been created.

Føyka Sweater

SIZES
S(M:L:XL:XXL)

TENSION (GAUGE)
10cm (4in) on 6mm (US 10) needles = 13 sts

YARN
Álafosslopi

Alternative: Blåne and/or Troll from Hillesvåg Ullvarefabrikk

AMOUNT OF YARN
Indigo (809959): 500(600:600:700:700)g
(17½[21¼:21¼:24½:24½]oz)
Light Denim Heather (800008):
100(200:200:200:200)g (3½[7:7:7:7]oz)
Light Ash Heather (800054):
100(200:200:200:200)g (3½[7:7:7:7]oz)

KNITTING NEEDLES
4.5mm & 6mm (US 7 & 10) double-pointed needles
4.5mm & 6mm (US 7 & 10) 40cm (16in) circular needles
4.5mm & 6mm (US 7 & 10) 80cm (30in) circular needles

MEASUREMENTS
Sleeves women: 47(48:49:50:51)cm
(18½[19:19¼:19¾:20]in)
Sleeves men: 50(51:52:53:54)cm
(19¾[20:20½:21:21¼]in)
Chest (unisex): 93(101:110:120:129)cm
(36½[39¾:43¼:47¼:50¾]in)
Body length women: 41(42:43:44:45)cm
(16¼[16½:17:17¼:17¾]in)
Body length men: 43(44:45:46:47)cm
(17[17¼:17¾:18¼:18½]in)

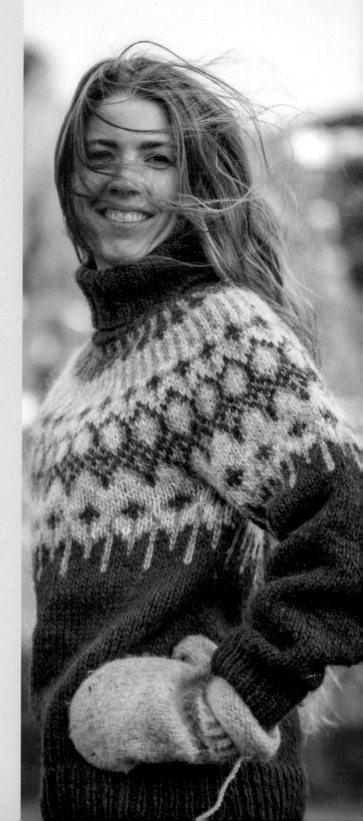

BODY

With 4.5mm (US 7) needle and Indigo, cast on 120(132:144:156:168) sts and work k1, p1 rib for 7cm (2¾in). Place a marker at the beginning of the round. Change to 6mm (US 10) circular needle (cont in st st in the round). Cont in Indigo until the body measures 29(30:31:32:33)cm (11½[11¾:12¼:12½:13]in) for women and 31(32:33:34:35) cm (12¼[12½:13:13½:13¾]in) for men. Work Chart A (if you knit tightly: go up one needle size when working charts). The body should now measure 41(42:43:44:45)cm (16¼[16½:17:17¼:17¾]in) for women and 43(44:45:46:47)cm (17[17¼:17¾:18¼:18½]in) for men (or desired length).

Place a marker after 60(66:72:78:84) sts so that you now have a marker on each side (= front and back piece). Place 7(9:12:11:11) sts from each side on scrap yarn or a stitch holder. Set the work aside and knit Sleeves.

SLEEVES

With 4.5mm (US 7) double-pointed needles and Indigo, cast on 34(36:38:42:42) sts and work k1, p1 rib for 7cm (2¾in). Change to 6mm (US 10) double-pointed needles (cont in st st) and inc 4 sts evenly across the first round = 38(40:42:46:46) sts. Place a marker around the middle st under the sleeve and inc 1 st on each side of the marked st every 2.5(2.5:2.5:3:3)cm (1[1:1:1¼:1¼]in) until there are 54(54:60:60:60) sts. Cont in Indigo until the piece measures 35(36:37:38:39)cm (13¾[14¼:14½:15:15¼]in) for women and 38(39:40:41:42)cm (15[15¼:15¾:16¼:16½]in) for men. Work Chart A (change needle size if necessary). The sleeve should now measure 47(48:49:50:51)cm (18½[19:19¼:19¾:20]in) for women and 50(51:52:53:54)cm (19¾[20:20½:21:21¼]in) for men (or desired length).

Place 8(9:12:10:10) sts from the middle of the sleeve on scrap yarn or a stitch holder. Knit the other sleeve the same way.

YOKE

Knit the Sleeves onto same needle as the Body. Place a marker at the first join to mark the beginning and end of the round. You should now have 198(204:216:234:246) sts on the needle. Work Chart B for the yoke (change needle size if necessary) and dec as shown in the chart.

NECK

Change to 4.5mm (US 7) needle and with Indigo, work k2, p2 rib for 20cm (8in) and cast (bind) off loosely in rib.

ASSEMBLY

Weave in loose ends and knit (or sew) together underneath the Sleeves. Place the sweater in a bucket of water (max. 30°C [86°F]) and leave it there until all the air is out of the sweater. Dry flat and stretch into shape. It is very important that you do not hang the sweater to dry, as this will make it stretch.

Chart A (Sleeves and Body)

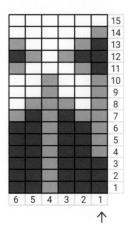

1 = Centre front on Sleeves and Body. Count from the middle where to begin knitting on the chart.

Chart B (Yoke)

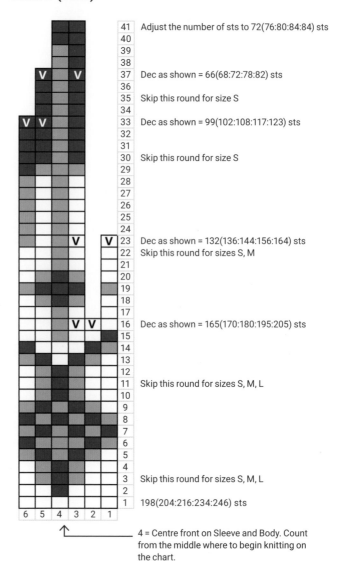

	
41	Adjust the number of sts to 72(76:80:84:84) sts
40	
39	
38	
37	Dec as shown = 66(68:72:78:82) sts
36	
35	Skip this round for size S
34	
33	Dec as shown = 99(102:108:117:123) sts
32	
31	
30	Skip this round for size S
29	
28	
27	
26	
25	
24	
23	Dec as shown = 132(136:144:156:164) sts
22	Skip this round for sizes S, M
21	
20	
19	
18	
17	
16	Dec as shown = 165(170:180:195:205) sts
15	
14	
13	
12	
11	Skip this round for sizes S, M, L
10	
9	
8	
7	
6	
5	
4	
3	Skip this round for sizes S, M, L
2	
1	198(204:216:234:246) sts

4 = Centre front on Sleeve and Body. Count from the middle where to begin knitting on the chart.

VV = Knit 2 stitches together (k2tog)
V = 1 stitch
M = stitch

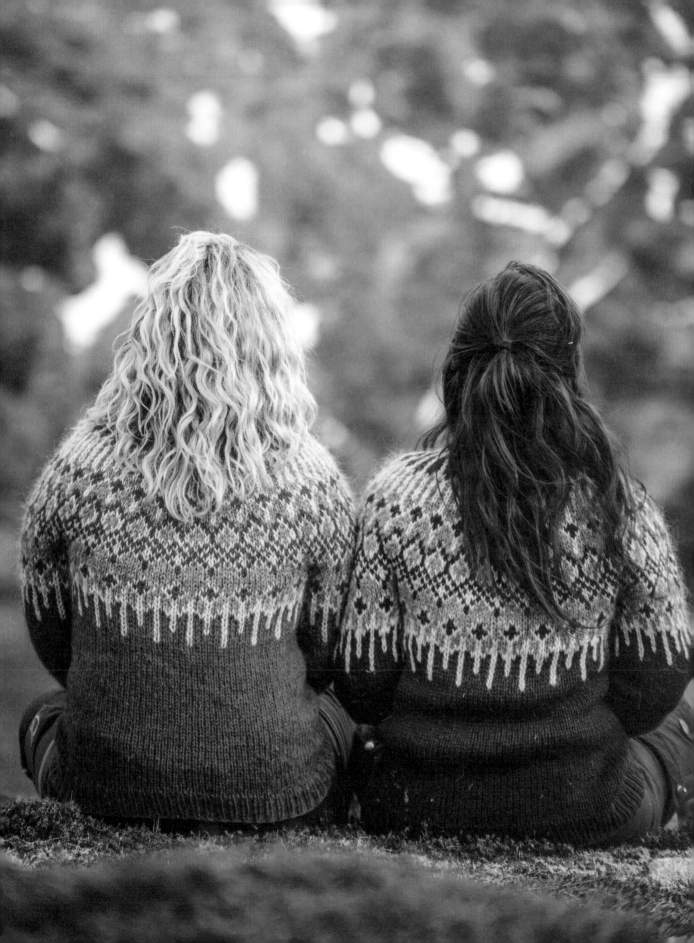

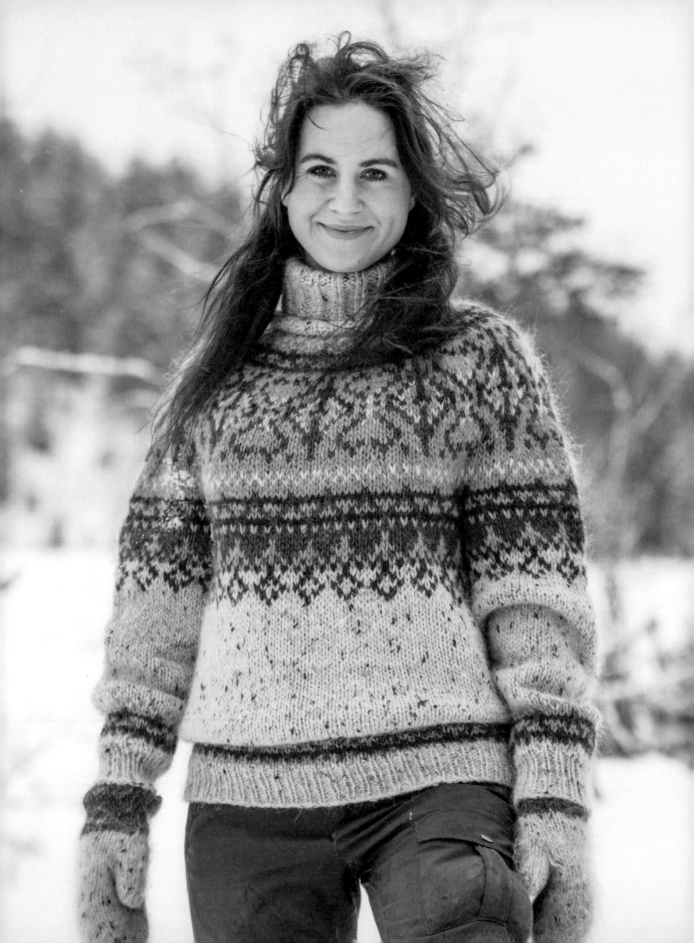

Alasuq

I grew up in Oslo, not far from the house of the adventurer Helge Ingstad. I loved visiting his daughter, Benedicte, and granddaughter, Marit, who still lived there with a bunch of Huskies. One of my favourites was called Alasuq.

This sweater is a little demanding to knit since parts of the pattern are knitted with three strands. Nevertheless, the result is so lovely that it's worth the time. I have made the Alasuq in both a thin and a thick variant.

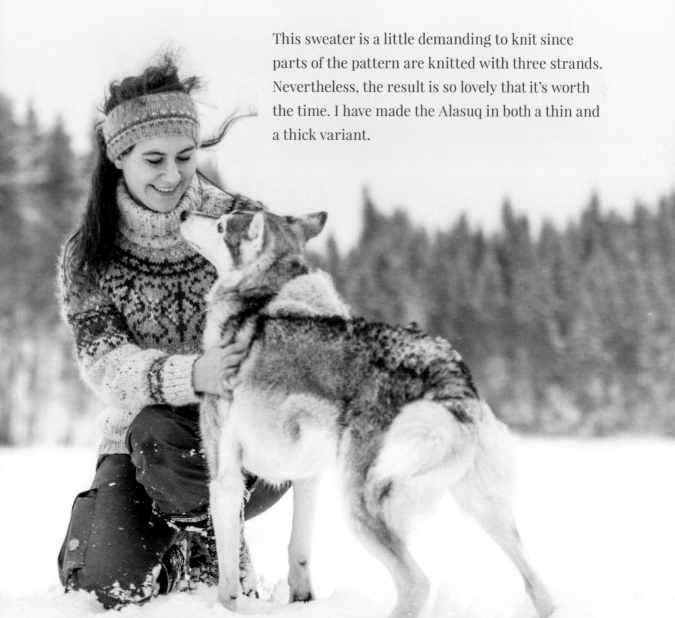

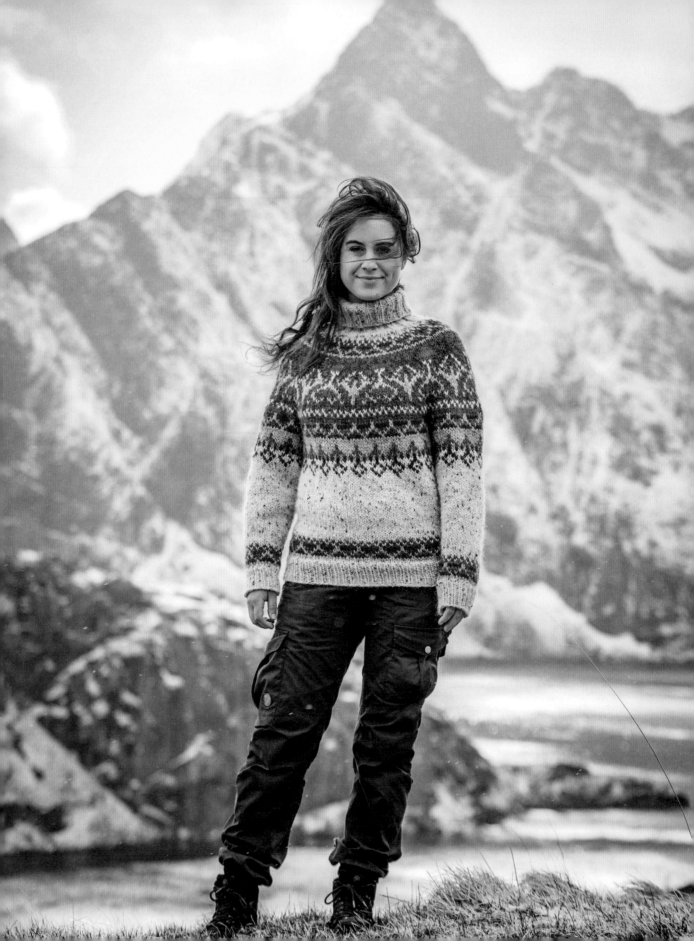

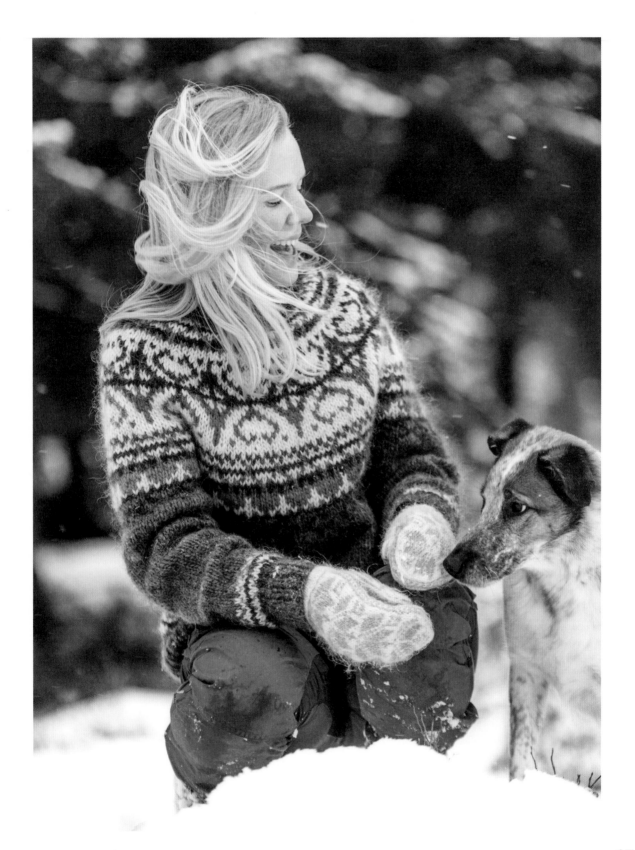

Alasuq Polar

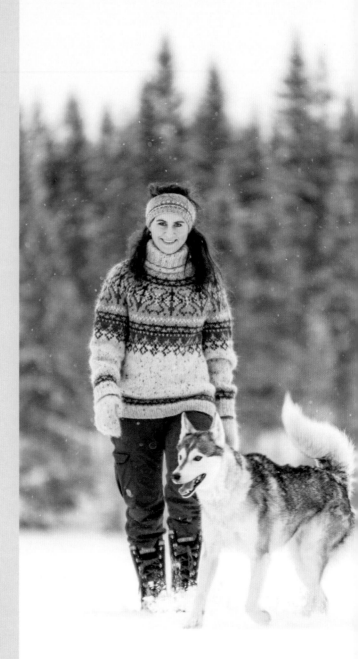

SIZES
S(M:L:XL:XXL)

TENSION (GAUGE)
10cm (4in) on 6mm (US 10) needle = 13 sts

YARN
Álafosslopi

AMOUNT OF YARN
Light Grey Tweed (809974): 400(500:600:700:700)g
(14[17½:21¼:24½:24½]oz)
Burnt Orange (801236): 100(100:200:200:200)g
(3½[3½:7:7:7]oz)
Golden Heather (809964): 100g (3½oz)
Cypress Green Heather (809966): 100g (3½oz)
Arctic Exposure (801232): 200g (7oz)

KNITTING NEEDLES
4.5mm & 6mm (US 7 & 10) double-pointed needles
4.5mm & 6mm (US 7 & 10) 40cm (16in) circular
needles
4.5mm & 6mm (US 7 & 10) 80cm (30in) circular
needles

MEASUREMENTS
Sleeves women: 47(48:49:50:51)cm
(18½[19:19¼:19¾:20]in)
Sleeves men: 50(51:52:53:54)cm
(19¾[20:20½:21:21¼]in)
(or desired length)
Chest (unisex): 93(101:110:120:130)cm
(36½[39¾:43¼:47¼:51¼]in)
Body length women: 41(42:43:44:45)cm
(16¼[16½:17:17¼:17¾]in)
Body length men: 43(44:45:46:47)cm
(17[17¼:17¾:18¼:18½]in)
(or desired length)

BODY

With 4.5mm (US 7) needle and Light Grey Tweed, cast on 120(132:144:156:168) sts and work k1, p1 rib for 7cm (2¾in). Place a marker at the beginning of the round. Change to 6mm (US 10) circular needle (cont in st st in the round) and work Chart A (if you knit tightly: go up one needle size when working charts). Cont in Light Grey Tweed until piece measures 30(31:32:33:34)cm (11¾[12¼:12½:13:13½]in) for women and 32(33:34:35:36)cm (12½[13:13½:13¾:14¼]in) for men. Work Chart B (change needle size if necessary). The body should now measure 41(42:43:44:45)cm (16¼[16½:17:17¼:17¾]in) for women and 43(44:45:46:47)cm (17[17¼:17¾:18¼:18½]in) for men (or desired length).

Place a marker after 60(66:72:78:84) sts so that you now have a marker on each side (= front and back piece). Place 7(9:12:11:11) sts from each side on scrap yarn or a stitch holder.

Set the work aside and knit Sleeves.

SLEEVES

With 4.5mm (US 7) double-pointed needles and Light Grey Tweed, cast on 34(36:38:42:42) sts and work k1, p1 rib for 7cm (2¾in). Change to 6mm (US 10) double-pointed needles (cont in st st) and inc 2(6:4:6:6) sts across first round = 36(42:42:48:48) sts. Work Chart A (change needle size if necessary) and cont in Light Grey Tweed. Place a marker around the middle st under the sleeve and inc 1 st on each side of the marked st every 2cm (¾in) until there are 54(54:60:60:60) sts. Cont in Light Grey Tweed until the piece measures 36(37:38:39:40)cm (14¼[14½:15:15¼:15¾]in) for women and 39(40:41:42:43)cm (15¼[15¾:16¼:16½:17]in) for men and work Chart B (change needle size if necessary). The sleeve should now measure 47(48:49:50:51)cm (18½[19:19¼:19¾:20]in) for women and 50(51:52:53:54)cm (19¾[20:20½:21:21¼]in) for men (or desired length).

Place 8(9:12:10:10) sts from the middle of the sleeve on scrap yarn or a stitch holder. Knit the other sleeve the same way.

YOKE

Knit the Sleeves onto same needle as the Body. Place a marker at the first join to mark the beginning and end of the round. You should now have 198(204:216:234:246) sts on the needle. Work Chart C (change needle size if necessary) and dec as shown in the chart.

NECK

Change to 4.5mm (US 7) needle and with Light Grey Tweed, work k2, p2 rib for 20cm (8in) and cast (bind) off loosely in rib.

ASSEMBLY

Weave in loose ends and knit (or sew) together underneath the Sleeves. Place the sweater in a bucket of water (max. 30°C [86°F]) and leave it there until all the air is out of the sweater. Dry flat and stretch into shape. It is very important that you do not hang the sweater to dry, as this will make it stretch.

Chart A

Chart B (Sleeves and Body)

3 = Centre front. Count from the middle where to begin knitting on the chart.

Chart C (Yoke)

Dec 36(38:40:42:42) sts evenly = 72(76:80:84:84) sts
Skip this round for sizes S, M
Skip this round for sizes S, M, L
Skip this round for sizes S, M, L

3 = Centre front. Count from the middle where to begin knitting on the chart.

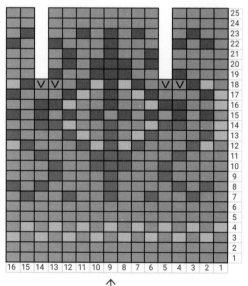

Dec 32(40:48:56:56) sts evenly = 108(114:120:126:126) sts

Dec as shown = 140(154:168:182:182) sts

Dec 38(28:24:26:38) sts evenly = 160(176:192:208:208) sts

Skip this round for size S
198(204:216:234:246) sts

9= Centre front. Count from the middle where to begin knitting on the chart.

VV = Knit 2 stitches together (k2tog)
V = 1 stitch
M = stitch

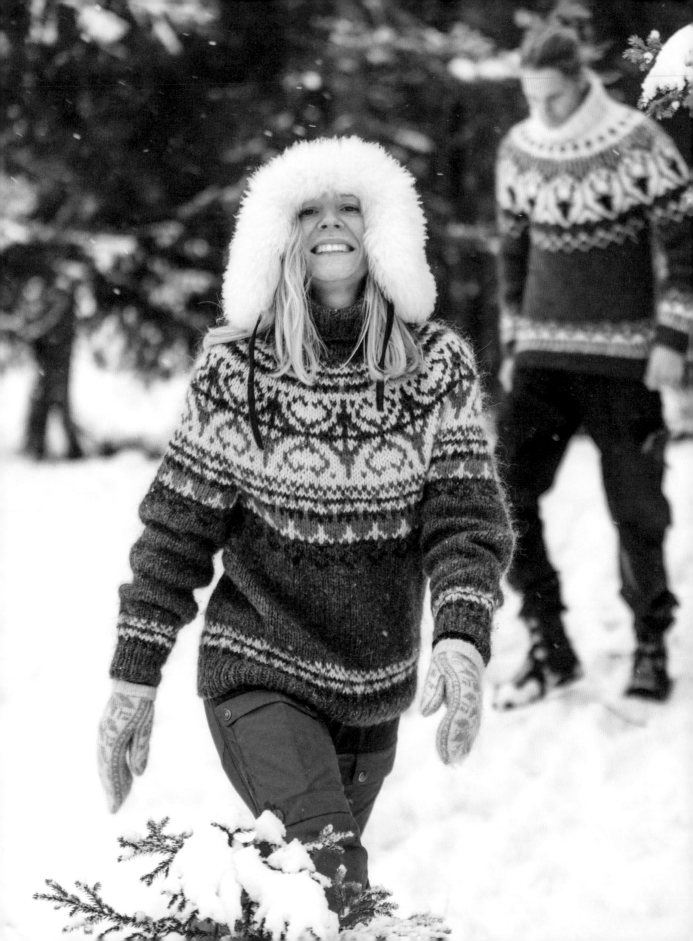

Alasuq Thin

SIZES
S(M:L:XL:XXL)

TENSION (GAUGE)
10cm (4in) on 3.5mm (US 4) needle = 22 sts

YARN
3-ply Strikkegarn from Rauma

AMOUNT OF YARN
Light Grey (103): 400(400:450:500:550)g
(14[14:15¾:17½:19½]oz)
Blue (155): 100(100:100:150:150)g
(3½[3½:3½:5¼:5¼]oz)
Red (144): 100(100:100:150:150)g
(3½[3½:3½:5¼:5¼]oz)
Yellow (131): 50g (1¾oz)
Green (15/61): 50(50:100:100:100)g
(1¾[1¾:3½:3½:3½]oz)

KNITTING NEEDLES
3mm & 3.5mm (US 2/3 & 4) double-pointed needles
3mm & 3.5mm (US 2/3 & 4) 40cm (16in) circular
needles
3mm & 3.5mm (US 2/3 & 4) 80cm (30in) circular
needles

MEASUREMENTS
Sleeves women: 47(48:49:50:51)cm
(18½[19:19¼:19¾:20]in)
Sleeves men: 50(52:53:54:55)cm
(19¾[20½:21:21¼:21¾]in)
(or desired length)
Chest (unisex): 90(101:109:116:127)cm
(35½[39¾:43:45¾:50]in)
Body length women: 40(42:42:43:43)cm
(15¾[16½:16½:17:17]in)
Body length men: 44(45:46:47:47)cm
(17¼[17¾:18¼:18½:18½]in)
(or desired length)

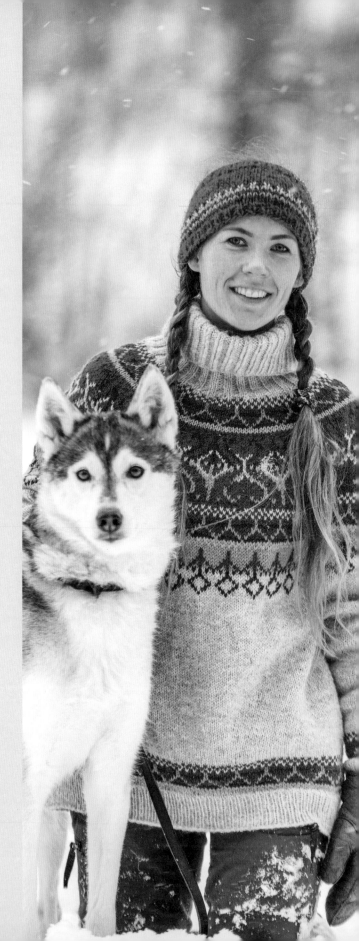

BODY

With 3mm (US 2/3) needle and Light Grey, cast on 200(224:240:256:280) sts and work k1, p1 rib for 6cm (2¼in). Place a marker at the beginning of the round. Change to 3.5mm (US 4) circular needle (cont in st st in the round) and work Chart A (if you knit tightly: go up one needle size when working charts). Cont in Light Grey until piece measures 34(36:36:37:37)cm (13½[14¼:14¼:14½:14½]in) for women and 40(42:42:43:43)cm (15¾[16½:16½:17:17]in) for men. Work Chart B (change needle size if necessary). The piece should now measure 40(42:42:43:43)cm (15¾[16½:16½:17:17]in) for women and 44(45:46:47:47)cm (17¼[17¾:18¼:18½:18½]in) for men.
Place a marker after 100(112:120:128:140) sts so that you now have a marker in each side (= front and back piece). Place 11 sts from each side on scrap yarn or a stitch holder (the marked stitch and 5 sts on each side). Set the work aside and knit Sleeves.

SLEEVES

With 3mm (US 2/3) double-pointed needles and Light Grey, cast on 42(48:48:54:54) sts and work k1, p1 rib for 6cm (2¼in). Change to 3.5mm (US 4) double-pointed needles (cont in st st) and inc 6(0:8:2:10) sts evenly on first round = 48(48:56:56:64) sts. Work Chart A (change needle size if necessary) and cont in Light Grey. Place a marker around the middle st under the sleeve and cast on 1 st on each side of the marked st every 1.5(1.5:1.5:2:2)cm (½[½:½:¾:¾]in) until there are 80(80:88:88:88) sts. Cont in Light Grey until piece measures 41(42:43:44:45)cm (16¼[16½:17:17¼:17¾]in) for women and 44(46:47:48:49)cm (17¼[18¼:18½:19:19¼]in) for men and work Chart B (change needle size if necessary). The sleeve should now measure 47(48:49:50:51) cm (18½[19:19¼:19¾:20]in) for women and 50(52:53:54:55)cm (19¾[20½:21:21¼:21¾] in) for men.
Place 11 sts from the middle of the sleeve on scrap yarn or a stitch holder (the marked st and 5 sts on each side).
Knit the other sleeve in the same way.

YOKE

Knit the Sleeves onto same needle as the Body. Place a marker at the first join to mark the beginning and end of the round. You should now have 316(340:372:388:412) sts on the needle. Work Chart C (change needle size if necessary) and dec as shown.

NECK

Work to the round specified in the chart. You should now have 112(116:116:120:120) sts on the needle. Change to 3mm (US 2/3) needle and work k2, p2 rib for 20cm (8in). Cast (bind) off loosely in rib.

ASSEMBLY

Weave in loose ends and knit (or sew) together underneath the Sleeves. Place the sweater in a bucket of water (max. 30°C [86°F]) and leave it there until all the air is out of the sweater. Dry flat and stretch into shape. It is very important that you do not hang the sweater to dry, as this will make it stretch.

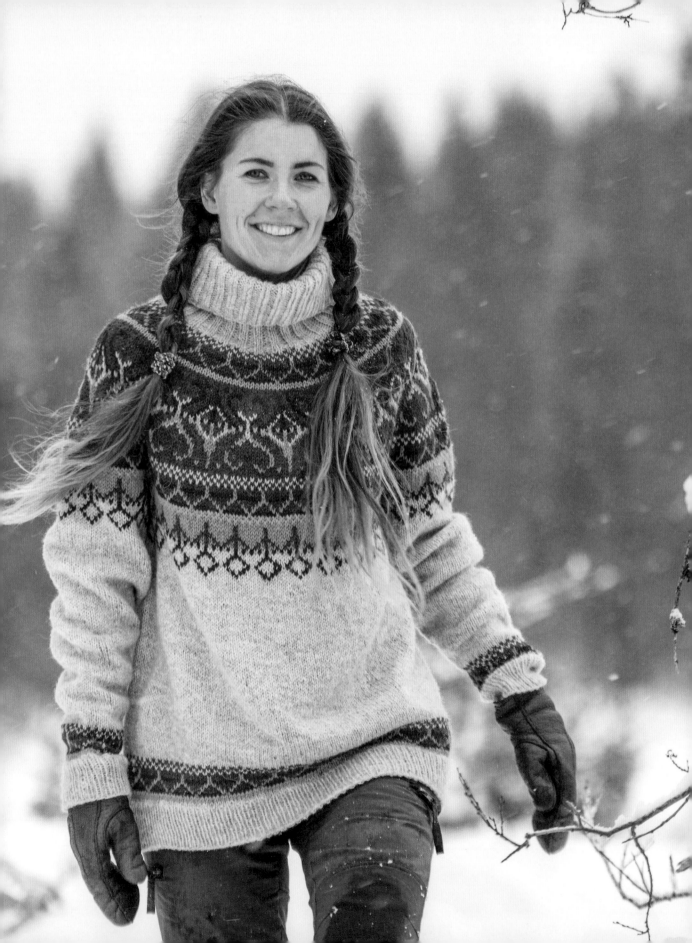

Chart A

Chart B

4 = Centre front. Count from the middle where to begin knitting on the chart.

Chart C (Yoke)

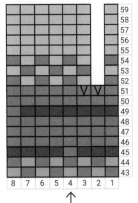

Dec 28(31:38:48:48) sts evenly = 112(116:116:120:120) sts
Skip this round for sizes S, M
Skip this round for sizes S, M, L
Skip this round for sizes S, M, L

Dec as shown = 140(147:154:168:168) sts

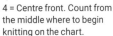

4 = Centre front. Count from the middle where to begin knitting on the chart.

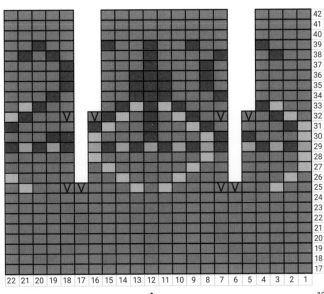

Skip this round for sizes S, M, L
Dec 56(66:76:78:96) sts evenly = 160(168:176:192:192) sts

Skip this round for sizes S, M

Dec as shown = 216(234:252:270:288) sts

Dec as shown = 240(260:280:300:320)sts

Skip this round for sizes S, M

Skip this round for sizes S, M, L

12 = Centre front. Count from the middle where to begin knitting on the chart.

VV = Knit 2 stitches together (k2tog)
V = 1 stitch
M = stitch

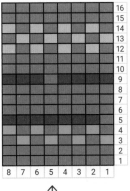

Dec 40(34:44:46:48) sts evenly = 264(286:208:330:352) sts

Dec 12(20:20:12:12) sts evenly = 304(320:352:376:400) sts
316(340:372:388:412) sts

5 = Centre front. Count from the middle where to begin knitting on the chart.

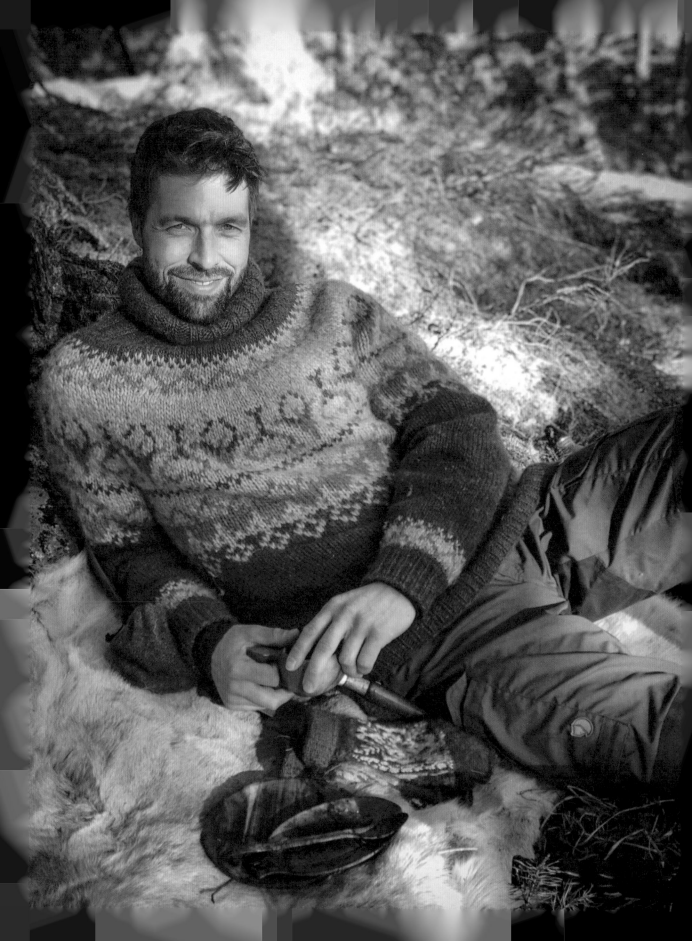

Fjordfolk

After designing the Wilderness sweater in Icelandic wool, I wanted
to make a thinner version in a traditional Norwegian pattern. In
this sweater I have combined my paw pattern with a classic motif.
Everyone has a different body shape. Some people find sweaters
with a seamless yoke the most comfortable, while others think
that sewn-on sleeves give a better fit. All the Fjordfolk sweaters
are knitted in Peer Gynt from Sandnes Yarn, a durable yarn from
Norwegian sheep. These sweaters will last year after year, and may
even be passed on to the next generation.

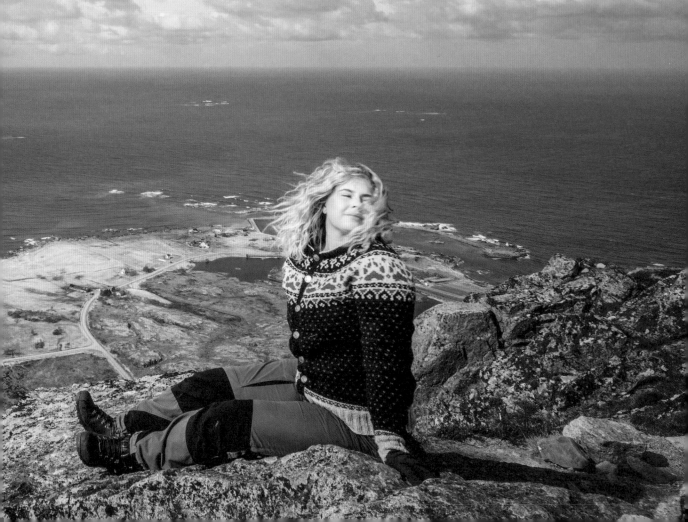

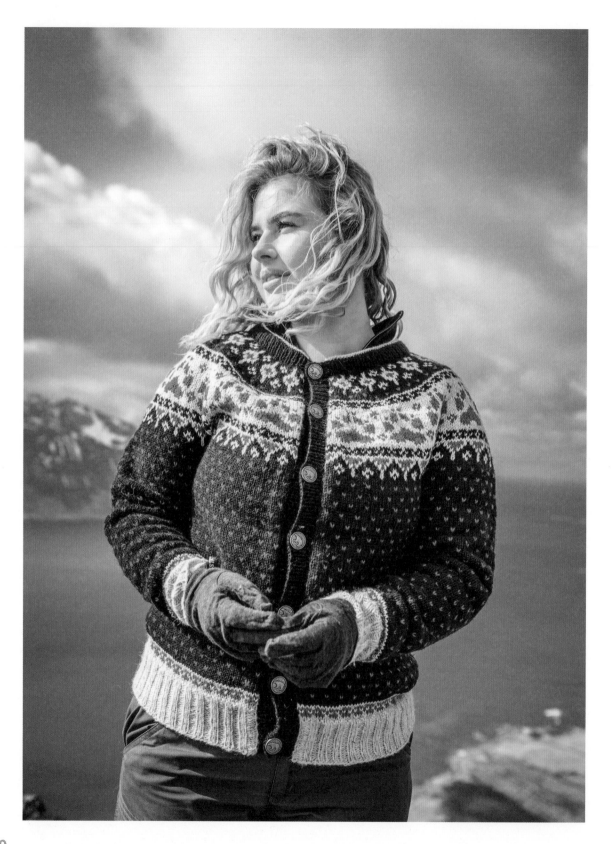

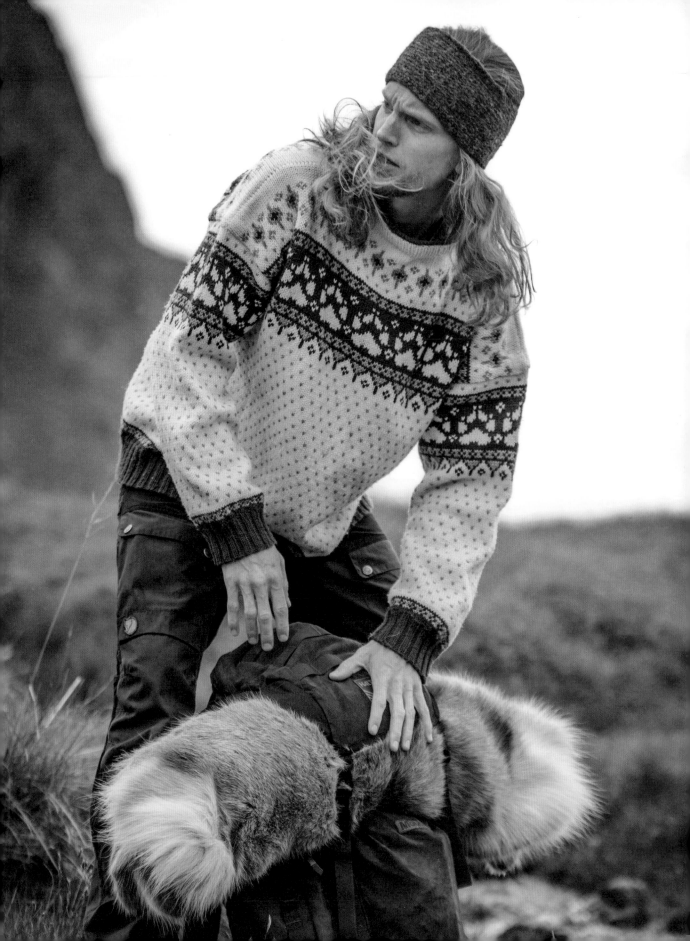

Fjordfolk with sewn-on sleeves

SIZES
S(M:L:XL:XXL:XXXL)

TENSION (GAUGE)
10cm (4in) on 3.5mm (US 4) needle = 22 sts

YARN
Peer Gynt from Sandnes Yarn

AMOUNT OF YARN
Dark Blue (6364) = 350(350:450:500:550:600)g
(12¼[12¼:15¾:17½:19½:21¼]oz)
White (1001) = 250(250:300:300:350:350)g
(8¾[8¾:10½:10½:12¼:12¼]oz)
Red (4228) = 150(150:200:200:200:200)g
(5¼[5¼:7:7:7:7:]oz)

KNITTING NEEDLES
3mm & 3.5mm (US 2/3 & 4) double-pointed needles
3mm & 3.5mm (US 2/3 & 4) 40cm (16in) circular
needles
3mm & 3.5mm (US 2/3 & 4) 80cm (30in) circular
needles

MEASUREMENTS
Sweaters with sewn-on sleeves give a better fit if
they are a little spacious. Measure your chest and
add 10cm (4in) to get the right size.

Sleeves women: 48(49:50:51:52:53)cm
(19[19¼:19¾:20:20½:21]in)
Sleeves men: 50(52:53:54:55:56)cm
(19¾[20½:21:21¼:21¾:22]in)
Chest (unisex): 90(101:109:116:124:130)cm
(35½[39¾:43:45¾:48¾:51¼]in)
Complete length women: 63(66:67:67:69:69)cm
(24¾[26:26¼:26¼:27¼:27¼]in)
Complete length men: 67(69:70:70:72:74)cm
(26¼[27¼:27½:27½:28¼:29¼]in)

FRONT AND BACK PIECE

With 3mm (US 2/3) circular needle and White, cast on 200(224:240:256:272:288) sts and work k2, p2 rib for 7cm (2¾in). Place a marker in each side so there are 100(112:120:128:136:144) sts for the front piece and 100(112:120:128:136:144) sts for the back piece. Change to 3.5mm (US 4) needle (cont in st st in the round) and work Chart A (if you knit tightly: go up one needle size when working charts). Work 3 rounds in Dark Blue and then work Chart B. Repeat Chart B until the piece measures 40(42:42:42:43:43)cm (15¾[16½:16½:16½:17:17]in) for women and 44(45:45:46:47:47) cm (17¼[17¾:17¾:18¼:18½:18½]in) for men (or desired length). Work Chart C (change needle size if necessary). After working Chart C, cont in Dark Blue until front and back piece measures 63(66:67:67:69:69)cm (24¾[26:26¼:26¼:27¼:27¼]in) for women and 67(69:70:70:72:74)cm (26¼[27¼:27½:27½:28¼:29¼]in) for men.
Set the work aside and knit Sleeves.

SLEEVES

With 3mm (US 2/3) double-pointed needles and White, cast on 48(52:52:52:56:56) sts and work k2, p2 rib for 7cm (2¾in). Change to 3.5mm (US 4) double-pointed needles (cont in st st) and inc the number of sts evenly on the first round to 64(64:64:64:72:72) sts. Work Chart A (change needle size if necessary). Work 3 rounds in Dark Blue and then work Chart B. Repeat Chart B until told to change.
Place a marker around the middle st under the sleeve and inc 1 st on each side of the marked st every 1.5cm (½in) for women and every 2cm (¾in) for men, until there are 96(96:104:104:104:106) sts (note: Chart D is not repeated in full on all sizes). Work until 16cm (6¼in) before sleeve length for size given in measurements and work Chart D (change needle size if necessary).
When you have finished working Chart D, turn the sleeve and work st st for 2cm (¾in) for the facing. The facing will be sewn over the raw edge on the inside of the sweater during assembly. Cast (bind) off loosely.
Knit the other sleeve the same way.

ASSEMBLY

Weave in loose ends and steam the sweater lightly (use a damp cloth or similar in between if you use an iron).
Sew two tight machine seams corresponding to the width of the sleeve. Knit or sew the shoulders together (place sts for the Neck on a spare needle - see below). Cut between the two seams. Sew on the Sleeves by hand or with a sewing machine. Finish off by sewing the facing over the raw edge. There is an instructional video on valleyknits.blog.

NECK

Insert the middle 41(45:51:51:53:55) sts from the Front Piece and the middle 41(45:51:51:53:55) sts from the Back onto 3mm (US 2/3) 40cm (16in) circular needle. Pick up 1 st from each shoulder to avoid holes where the neck meets the shoulder. You should now have 84(92:104:104:108:112) sts on the needle. With Dark Blue, work k1, p1 rib for 3cm (1¼in). Change to White and knit 1 round then purl 1 round. Cont to knit for 3cm (1¼in). Cast (bind) off loosely. Fold and sew down the neck.

Chart A

Chart B

↑
3 = Centre front on Sleeve and
Front and Back Piece.
Count from the middle where to
begin knitting on the chart.

Chart C (Front and Back Piece)

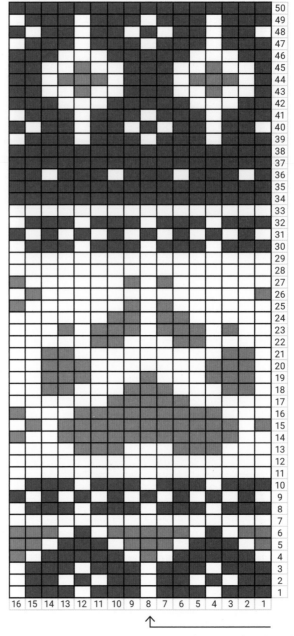

Cont in Dark Blue until
the work measures
given length.

↑
8 = Centre front. Count from the middle
where to begin knitting on the chart.

Chart D (Sleeve)

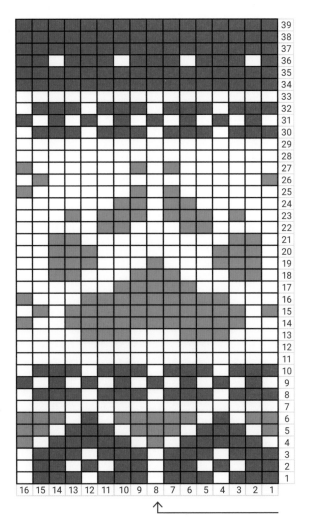

8 = Centre front. Count from the middle
where to begin knitting on the chart.

Fjordfolk with round yoke

SIZES
S(M:L:XL:XXL:XXXL)

TENSION (GAUGE)
10cm (4in) on 3.5mm (US 4) needle = 22 sts

YARN
Peer Gynt from Sandnes Yarn

AMOUNT OF YARN
Red (4228) = 450(500:550:600:600:650)g
(15¾[17½:19½:21¼:21¼:23]oz)
Grey-Beige Mottled (2650) =
150(150:150:150:200:200)g (5¼[5¼:5¼:5¼:7:7]oz)
Brown (3082) = 150(150:150:150:200:200)g
(5¼[5¼:5¼:5¼:7:7]oz)

KNITTING NEEDLES
3mm & 3.5mm (US 2/3 & 4) double-pointed needles
3mm & 3.5mm (US 2/3 & 4) 40cm (16in) circular
needles
3mm & 3.5mm (US 2/3 & 4) 80cm (30in) circular
needles

MEASUREMENTS
Sleeves: 46(47:48:49:50:51)cm
(18¼[18½:19:19¼:19¾:20]in)
Chest: 90(101:109:116:124:130)cm
(35½[39¾:43:45¾:48¾:21¼]in)
Body length: 40(42:42:43:43:44)cm
(15¾[16½:16:17:17:17¼]in)

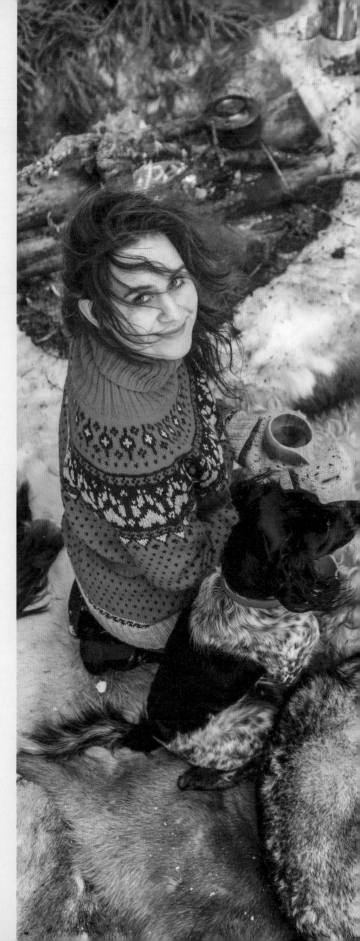

BODY

With 3mm (US 2/3) circular needle and Grey-Beige Mottled, cast on 200(224:240:256:272:288) sts and work k2, p2 rib for 7cm (2¾in). Place a marker at the beginning of the round and after 100(112:120:128:136:144) sts so that you now have a marker on each side (= front and back piece). Change to 3.5mm (US 4) needle (cont in st st in the round) and work Chart A (if you knit tightly: go up one needle size when working charts). Work 3 rounds in Red and then work Chart B. Repeat Chart B until the piece measures 40(42:42:43:43:44)cm (15¾[16½:16:17:17:17¼]in) (or desired length). Finish off with a row of lice stitches. Place 11 sts from each side on scrap yarn or a stitch holder (the marked st and 5 sts on each side).
Set the work aside and knit Sleeves.

SLEEVES

With 3mm (US 2/3) double-pointed needles and Grey-Beige Mottled, cast on 40(44:44:44:48:48) sts and work k2, p2 rib for 7cm (2¾). Change to 3.5mm (US 4) double-pointed needles (cont in st st) and inc the number of sts evenly to 48(52:52:52:56:56) sts. Place a marker around the middle st under the sleeve (the beginning of round). Always work this marked st in purl, as it is easier to keep track of where the round begins and ends. Work Chart A (change needle size if necessary). Work 3 rounds in Red then work Chart B. Repeat Chart B until told to change. Inc 1 st each side of the marked st every 2cm (¾in) until there are 74(78:82:82:86:86) sts. Work until the sleeve measures 46(47:48:49:50:51)cm (18¼[18½:19:19¼:19¾:20]in), or desired length. Finish off with a row of lice stitches. Place 11 sts from under the sleeve on scrap yarn or a stitch holder (the marked st and 5 sts on each side).
Put the piece aside and knit the other sleeve the same way.

YOKE

Knit the Sleeves onto same needle as the Body = 304(336:360:376:400:416) sts and work Chart C (change needle size if necessary). Dec as shown in the chart and finish at the round specified for your size.

NECK

Work to the round specified on the chart. You should now have 140(147:154:154:168:168) sts on the needle. Work 1 round in Red while dec evenly to 120(120:124:124:128:128) sts. Change to 3mm (US 2/3) needle and work k2, p2 rib for 20cm (8in) (or desired length). Cast (bind) off loosely.

ASSEMBLY

Weave in loose ends and knit (or sew) together underneath the Sleeves. Place the sweater in a bucket of water (max. 30°C [86°F]) and leave it there until all the air is out of the sweater. Dry flat and stretch into shape. It is very important that you do not hang the sweater to dry, as this will make it stretch.

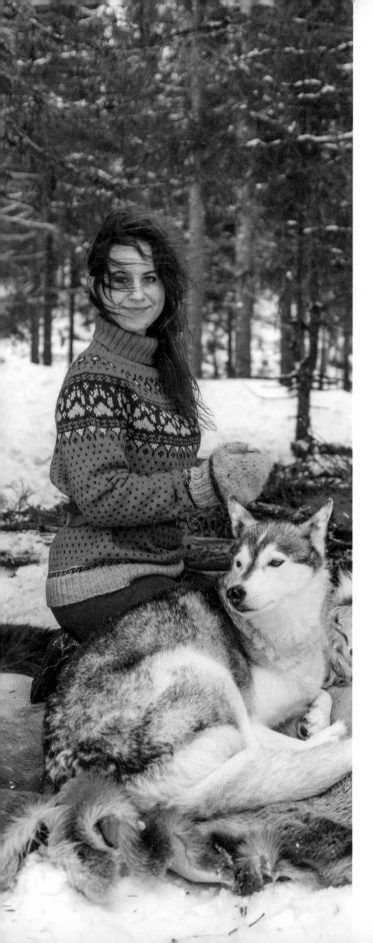

Chart A

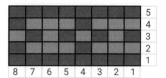

Chart B

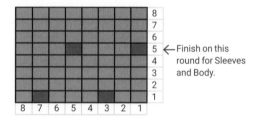

←Finish on this round for Sleeves and Body.

3 = Centre front on Sleeve and Body. Count from the middle where to begin knitting on the chart.

VV = Knit 2 stitches together (k2tog)
V = 1 stitch
M = stitch

Chart C (Yoke)

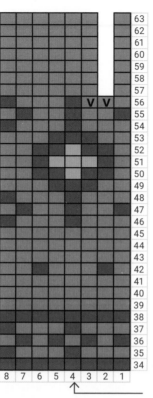

63 Finish for sizes XL, XXL, XXXL. See Neck in pattern.
62
61 Finish for sizes M, L. See Neck in pattern.
60
59 Finish for size S. See Neck in pattern.
58
57
56 Dec as shown = 140(147:154:154:168:168) sts
55
54
53
52
51
50
49
48
47
46
45 Skip this round for size S
44 Dec 48(56:64:64:64:64) sts evenly = 160(168:176:176:192:192) sts
43
42
41 Skip this round for size S
40
39
38
37
36
35
34 Skip this round for sizes S, M, L

8 7 6 5 4 3 2 1

4 = Centre front on Sleeves and Body.
Count from the middle where to begin knitting on the chart.

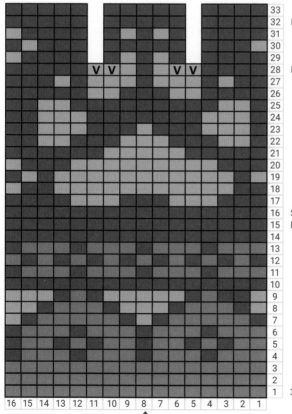

33
32 Dec 30(28:26:26:24:38) sts evenly = 208(224:240:240:256:256) sts
31
30
29
28 Dec as shown = 238(252:266:266:280:294) sts
27
26
25
24
23
22
21
20
19
18
17
16 Skip this round for sizes S, M, L
15 Dec 32(48:56:72:80:80) sts evenly = 272(288:304:304:320:336) sts
14
13
12
11
10
9
8
7
6
5
4
3
2
1 304(336:360:376:400:416) sts

16 15 14 13 12 11 10 9 8 7 6 5 4 3 2 1

8 = Centre front on Sleeve and Body.
Count from the middle where to begin knitting on the chart.

59

Fjordfolk Cardigan

SIZES
S(M:L:XL:XXL)

TENSION (GAUGE)
10cm (4in) on 3.5mm (US 4) needle = 22 sts

YARN
Peer Gynt from Sandnes Yarn

AMOUNT OF YARN
Charcoal (1088) = 450(500:550:600:600)g
(15¾[17½:19½:21¼:21¼]oz)
Red (4228) = 200g (7oz)
Light-Grey Mottled (1012) = 200(200:250:250:250)g
(7[7:8¾:8¾:8¾]oz)

BUTTONS
7(7:8:8:8) 22mm (1in) tin buttons

KNITTING NEEDLES
3mm & 3.5mm (US 2/3 & 4) double-pointed needles
3mm & 3.5mm (US 2/3 & 4) 40cm (16in) circular
needles
3mm & 3.5mm (US 2/3 & 4) 80cm (30in) circular
needles

MEASUREMENTS
Sleeves: 46(47:48:49:50)cm
(18¼[18½:19:19¼:19¾]in)
Chest: 93(104:112:119:127)cm
(36½[41:44:46¾:50]in)
Body length: 40(42:42:43:43)cm
(15¾[16½:16½:17:17]in)

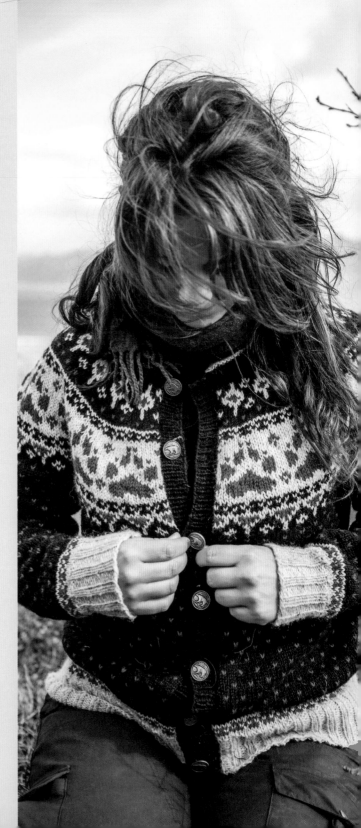

BODY

With 3mm (US 2/3) needle and Light-Grey Mottled, cast on 200(224:240:256:272) sts and work k2, p2 rib back and forth for 7cm (2¾in). The first row is the wrong side, so purl the first st (it is important that the outer sts are knit for picking up Button Bands later). Cast on 5 sts on the right needle for steek stitches. These need to be constantly worked in purl (they are not included in stitch counts). Change to 3.5mm (US 4) circular needle and inc 1 st on first round = 201(225:241:257:273) sts. Cont in st st in the round. Place markers in each side so there are 50(56:60:64:68) sts for each front piece and 101(113:121:129:137) sts for the back piece. Work Chart A (if you knit tightly: go up one needle size when working charts). Work 3 rounds in Charcoal and work Chart B. Repeat Chart B until work measures approximately 40(42:42:43:43) cm (15¾[16½:16½:17:17]in, or desired length. Finish with a row of lice stitches. Place 11 sts from each side on scrap yarn or a stitch holder (the marked st and 5 sts on each side). Put piece aside and knit Sleeves.

SLEEVES

With 3mm (US 2/3) double-pointed needles and Light-Grey Mottled, cast on 40(44:44:44:48) sts and work k2, p2 rib for 7cm (2¾in). Change to 3.5mm (US 4) double-pointed needles (cont in st st) while inc the number of sts evenly to 48(52:52:52:56) sts. Mark the middle st under the sleeve (the beginning of the round). Always purl this (the marked st) to make it easier to keep track of where the round begins and ends. Work Chart A (change needle size if necessary). Work 3 rounds in Charcoal. Work Chart B and repeat until told to change. Inc 1 st on each side of marked st every 2cm (¾in) until there are 74(78:82:82:86) sts. Work until the sleeve measures 46(47:48:49:50)cm (18¼[18½:19:19¼:19¾]in) (or desired length). Finish off with a row of lice stitches. Place 11 sts under the sleeve on scrap yarn or a stitch holder (the marked st and 5 sts on each side).
Put the piece aside and knit the other sleeve in the same way.

YOKE

Knit the Sleeves onto same needle as the Body = 305(337:361:377:401) sts and work Chart C for the yoke (change needle size if necessary). Dec as shown in the chart, and work to the round specified for your size.

NECK

You should now have 141(148:155:155:169) sts on the needle. Work 1 round in Charcoal dec evenly to 121(121:125:125:129) sts. Cast (bind) off the steek stiches. Change to 3mm (US 2/3) needle and work k1, p1 rib back and forth for 3cm (1¼in). Change to Light-Grey Mottled and work 1 row st st (knit the right side, purl the wrong side) and then 1 row reverse st st (knit the wrong side, purl the right side) for the folding edge. Cont in st st back and forth for 3cm (1¼in). Cast (bind) off loosley. Fold and sew in the neck.

ASSEMBLY

Weave in ends and knit (or sew) together underneath the sleeves. Sew two machine seams along the edges of the steek stitches. Sew three times to make sure the seams hold and nothing unravels. Cut between the two seams and work Button Bands.

Right Button Band

With 3mm (US 2/3) needle, pick up sts along right front piece in Charcoal. *Pick up 3 sts, skip 1 st,* rep from * to * to end. The number of sts must be divisible by 2 + 1 so that both the first and last are knit sts. Work k1, p1 rib for 3cm (1¼in). Cast (bind) off in rib.

Left Button Band

Work as the Right Button Band, but with 7(7:8:8:8) buttonholes evenly spaced after 1.5cm (½in). Place the lowest buttonhole approximately 2cm (¾in) from the bottom edge and the top approximately 1cm (½in) from the top edge. Work 1.5cm (½in) and cast (bind) off in rib.

Buttonholes

Knit 2 sts together and yarn over. If you prefer, you can also cast (bind) off 1 st, then cast on again on the next row.

Facing

Pick up sts on the wrong side of the Button Bands (the first sts in the first row). Work 2cm (¾in) st st back and forth and sew the facing over the raw edge. Alternatively, sew a ribbon over the raw edge.

Place the cardigan in a bucket of water (max. 30°C [86°F]) and leave it there until all the air is out of the cardigan. Dry flat and stretch into shape. It is very important that you do not hang the cardigan to dry, as this will make it stretch.

Chart A

Chart B

← Finish Sleeves and Body

↑ Begin here

VV = Knit 2 stitches together (k2tog)
V = 1 stitch
M = stitch

62

Chart C (Yoke)

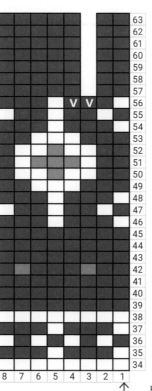

63	Finish for sizes XL, XXL. See Neck in pattern.
62	
61	Finish for sizes M, L. See Neck in pattern.
60	
59	Finish for size S. See Neck in pattern.
58	
57	
56	Dec as shown = 141(148:155:155:169) sts
55	
54	
53	
52	
51	
50	
49	
48	
47	
46	
45	Skip this round for size S
44	Dec 48(56:64:64:64) sts evenly = 161(169:177:177:193) sts
43	
42	
41	Skip this round for size S
40	
39	
38	
37	
36	
35	
34	Skip this round for sizes S, M, L

Begin here

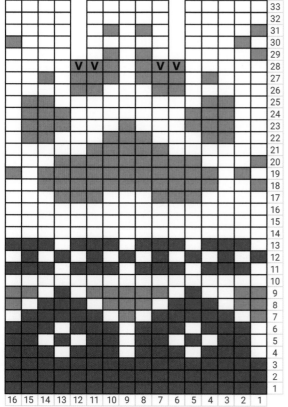

33	Dec 30(28:26:26:24) sts evenly = 209(225:241:241:257) sts
32	
31	
30	
29	
28	Dec as shown = 239(253:267:267:281) sts
27	
26	
25	
24	
23	
22	
21	
20	
19	
18	
17	
16	Skip this round for sizes S, M, L
15	Dec 32(48:56:72:80) sts evenly = 273(289:305:305:321) sts
14	
13	
12	
11	
10	
9	
8	
7	
6	
5	
4	
3	
2	
1	305(337:361:377:401) sts

Begin here

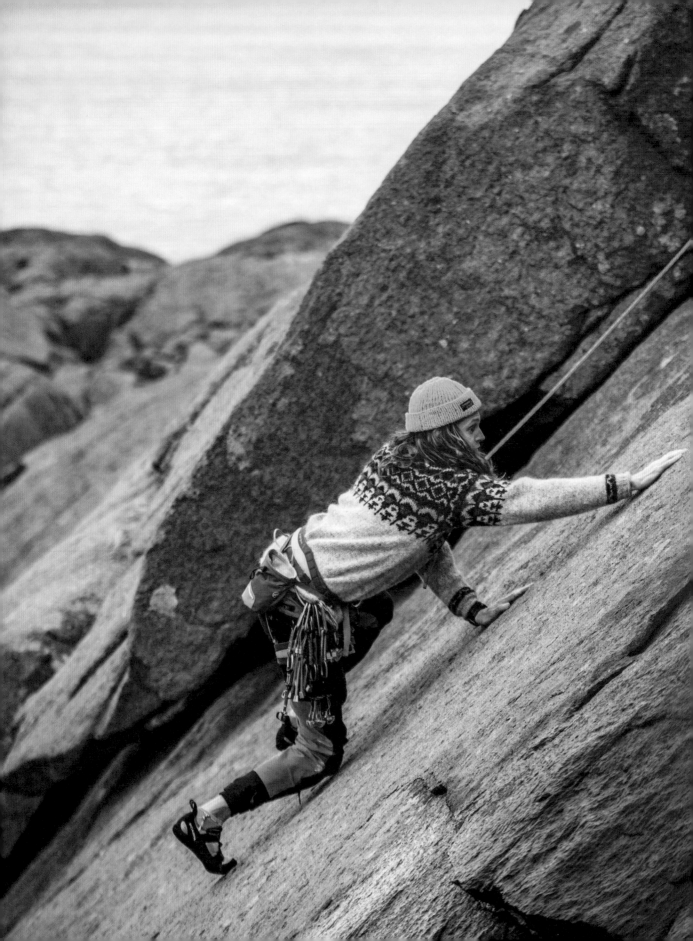

Matoaka

The Native Americans inspired
me when designing this sweater,
and I chose to call it Matoaka,
Pocahontas's real name.

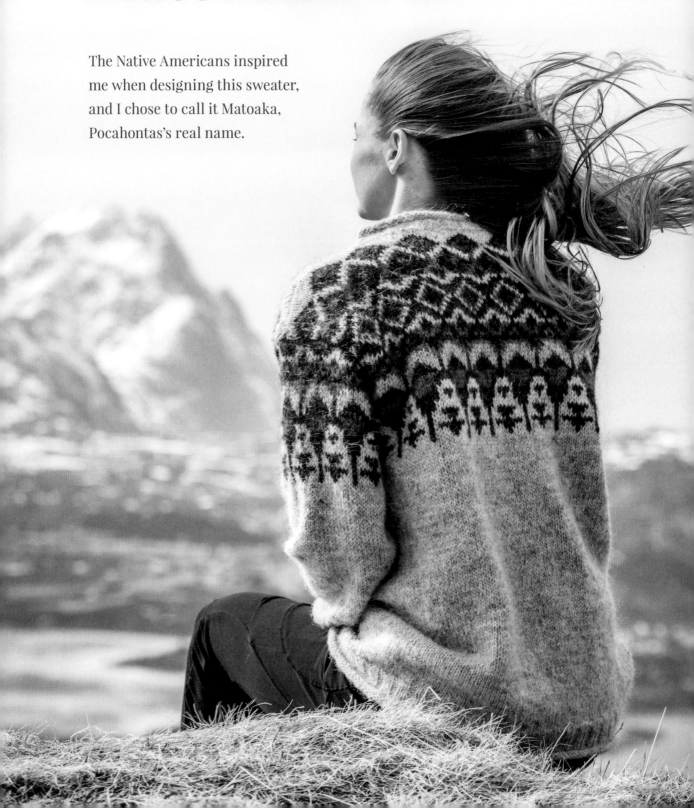

Matoaka Sweater

SIZES
S(M:L:XL:XXL)

TENSION (GAUGE)
10cm (4in) on 4.5mm (US 7) needle = 18 sts

YARN
Léttlopi

AMOUNT OF YARN
Low neck:
Light Ash Heather (0054) = 350(350:400:450:450)g
(12¼[12¼:14:15¾:15¾]oz)
Rust Heather (9427) = 100g (3½oz)
Air Blue (1700) = 50(50:50:50:100)g
(1¾[1¾:1¾:1¾:3½]oz)
Black (0059) = 150g (5¼oz)

High neck:
Approx. 50g (1¾oz) extra in the base colour

KNITTING NEEDLES
3.5mm & 4.5mm (US 4 & 7) double-pointed needles
3.5mm & 4.5mm (US 4 & 7) 40cm (16in) circular
needles
3.5mm & 4.5mm (US 4 & 7) 80cm (30in) circular
needles

MEASUREMENTS
For best fit, add 10cm (4in) to chest measurement.

Sleeves women: 49(50:51:52:53)cm
(19¼[19¾:20:20½:21]in)
Sleeves men: 54(55:56:57:58)cm
(21¼[21¾:22:22½:22¾]in)
Chest (unisex): 94(100:111:122:133)cm
(37[39½:43¾:48:52¼]in)
Complete length women: 63(65:66:67:69)cm
(24¾[25½:26:26¼:27¼]in)
Complete length men: 67(69:70:72:74)cm
(26¼[27¼:27½:28¼:29¼]in)

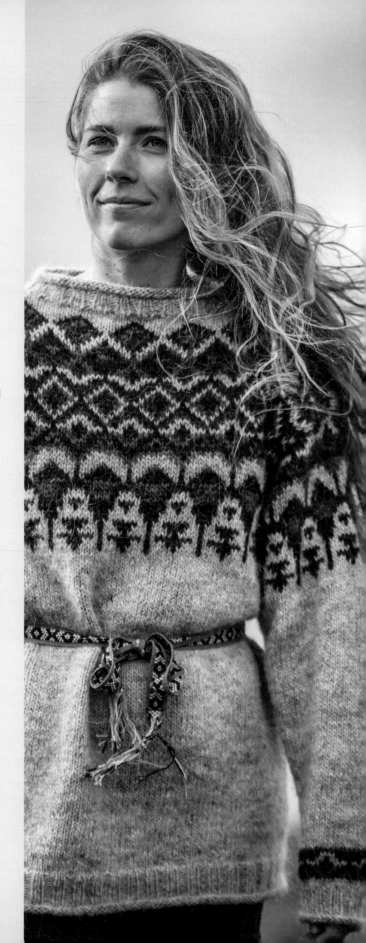

FRONT AND BACK PIECE

With 3.5mm (US 4) needle and Light Ash Heather, cast on 170(180:200:220:240) sts and knit 6 rounds for rolled edge. Then work k2, p2 rib for 4cm (1½in). Change to 4.5mm (US 7) circular needle (cont in st st in the round) and cont in Light Ash Heather until piece measures 32(34:35:36:38)cm (12½[13½:13¾:14¼:15]in) for women and 36(38:39:41:43)cm (14¼[15:15¼:16¼:17]in) for men.

Place a marker at the beginning of the round and after 85(90:100:110:120) sts (to mark front and back piece). Work Chart A (if you knit tightly: go up one needle size when working charts). Put the piece aside and knit Sleeves.

SLEEVES

With 3.5mm (US 4) double-pointed needles and Light Ash Heather, cast on 40(40:40:44:44) sts knit 6 rounds for rolled edge. Then work k2, p2 rib for 4cm (1½in). Change to 4.5mm (US 7) double-pointed needles (cont in st st) and inc evenly to 50(50:50:60:60) sts. Work Chart B (change needle size if necessary). Mark the middle st under the sleeve and inc 1 st on each side of the marked st every 1.5cm (½in) until there are 80(80:80:90:90) sts. Cont in Light Ash Heather until piece measures 32(33:34:35:36)cm (12½[13:13½:13¾:14¼]in) for women and 37(38:39:40:41) cm (14½[15:15¼:15¾:16¼]in) for men, and work Chart C (change needle size if necessary). The sleeve should now measure 49(50:51:52:53)cm (19¼[19¾:20:20½:21] in) for women and 54(55:56:57:58)cm (21¼[21¾:22:22½:22¾]in) for men. Turn the sleeve and knit 4 rounds for the facing. The facing will be sewn over the raw edge on the inside of the sweater during the assembly. Knit the other sleeve the same way.

ASSEMBLY

Weave in loose ends and steam the sweater lightly (use a damp cloth or similar in between if you use an iron).

Sew two tight machine seams corresponding to the width of the sleeve. Knit or sew the shoulders together (place sts for the neck on a spare needle - see below). Cut between the two seams. Sew on the Sleeves by hand or with a sewing machine. Finish off by sewing the facing over the raw edge. There is an instructional video on valleyknits.blog.

NECK

Low neck: Insert the middle 45(45:47:47:49) sts from the front piece and the middle 45(45:47:47:49) sts from the back piece onto 3.5mm (US 4) 40cm (16in) circular needle. Pick up 1 st from each shoulder to avoid holes where the neck meets the shoulder. You should now have 92(92:96:96:100) sts on the needle. With Light Ash Heather work k2, p2 rib for 3cm (1¼in) then knit 6 rounds for rolled edge. Cast (bind) off loosely.

High neck: Work as for low neck, but work k2, p2 rib for 20cm (8in) and then cast (bind) off loosely in rib.

Place the sweater in a bucket of water (max. 30°C [86°F]) and leave it there until all the air is out of the sweater. Dry flat and stretch into shape. It is very important that you do not hang the sweater to dry, as this will make it stretch.

Chart A (Front and Back Piece)

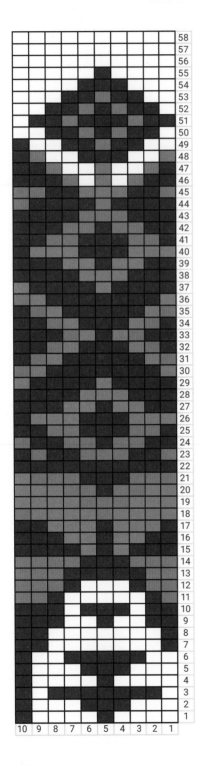

Chart B (Sleeves)

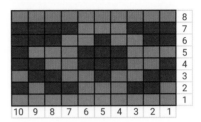

Chart C (Sleeves)

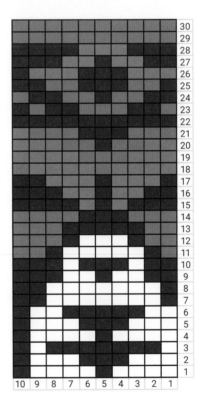

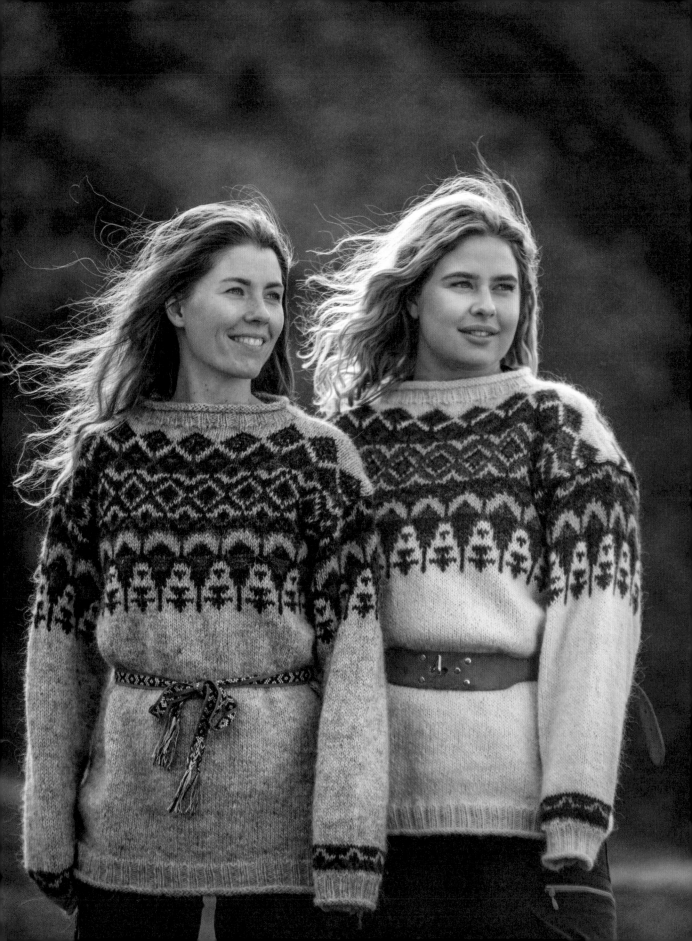

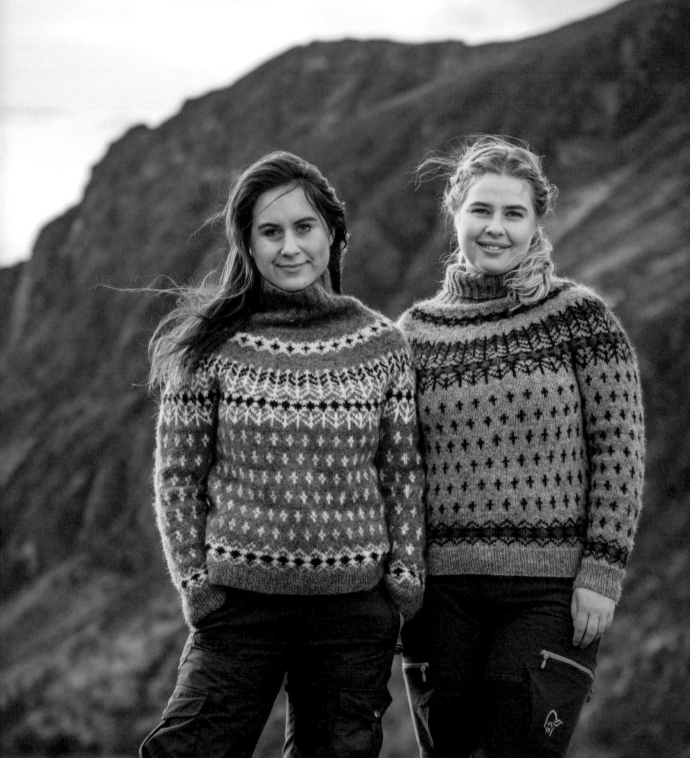

Galdrer

I designed this sweater in the autumn. Galdrer means "magic song" in Norse. I have tried to capture the mystical atmosphere that arises on a late autumn evening in front of the fire.

Galdrer Sweater

SIZES
S(M:L:XL:XXL)

TENSION (GAUGE)
10cm (4in) on 3.5mm (US 4) needle = 22 sts

YARN
Tinde from Hillesvåg Ullvarefabrikk

AMOUNT OF YARN
Natural Grey (652115) = 400(400:500:500:600)g
(14[14:17½:17½:21¼]oz)
Dark Brown (652116) = 100(200:200:200:200)g
(3½[7:7:7:7]oz)
Cognac (652103) = 100g (3½oz)

KNITTING NEEDLES
3mm & 3.5mm (US 2/3 & 4) double-pointed needles
3mm & 3.5mm (US 2/3 & 4) 40cm (16in) circular
needles
3mm & 3.5mm (US 2/3 & 4) 80cm (30in) circular
needles

MEASUREMENTS
Sleeves women: 47(48:49:50:51)cm
(18½[19:19¼:19¾:20]in)
Sleeves men: 50(52:53:54:55)cm
(19¾[20½:21:21¼:21¾]in)
Chest (unisex): 90(98:111:120:125)cm
(35½[38½:43¾:47¼:49¼]in)
Body length women: 40(42:43:44:44)cm
(15¾[16½:17:17¼:17¼]in)
Body length men: 44(45:46:47:47)cm
(17¼[17¾:18¼:18½:18½]in)
(or desired length)

BODY

With 3mm (US 2/3) circular needle and Natural Grey, cast on 198(216:246:264:276) sts and work k2, p2 rib for 6cm (2¼in). Change to 3.5mm (US 4) circular needle (cont in st st in the round) and work Chart A (if you knit tightly: go up one needle size when working charts). Place a marker at the beginning of the round and after 99(108:123:132:138) sts so that you now have a marker on each side (= front and back piece). Work Chart B and repeat until the piece measures 40(42:43:44:44)cm (15¾[16½:17:17¼:17¼]in) for women or 44(45:46:47:47)cm (17¼[17¾:18¼:18½:18½] in) for men (or desired length). Work 1 round in Natural Grey. Place 11 sts from each side of body on scrap yarn or a stitch holder (the marked st and 5 sts on each side). Put the piece aside and knit Sleeves.

SLEEVES

With 3mm (US 2/3) double-pointed needles and Natural Grey, cast on 42(48:54:54:54) sts and work k1, p1 rib for 6cm (2¼in). Change to 3.5mm (US 4) double-pointed needles (cont in st st) and inc 6 sts evenly to 48(54:60:60:60) sts. Work Chart A (change needle size if necessary) and cont with Chart B. Mark the middle st under the sleeve (beginning of the round) and inc 1 st on each side every 2cm (¾in) until there are 74(78:86:86:90) sts. Repeat Chart B until the piece measures 47(48:49:50:51)cm (18½[19:19¼:19¾:20]in) for women or 50(52:53:54:55) cm (19¾[20½:21:21¼:21¾]in) for men. Work 1 round in Natural Grey.
Place 11 sts under the sleeve on scrap yarn or a stitch holder (the marked st and 5 sts on each side).
Knit the other sleeve the same way.

YOKE

Knit the Sleeves onto same needle as the Body = 302(328:374:392:412) sts and work Chart C for the yoke (change needle size if necessary). Dec as shown in the chart.

NECK

Work to the round specified on the chart. You should now have 120(132:148:156:164) sts on the needle. Work 1 round while dec evenly to 112(116:116:120:120) sts. Change to 3mm (US 2/3) needle and work k2, p2 rib for 20cm (8in). Cast (bind) off loosely.

ASSEMBLY

Weave in ends and knit (or sew) together underneath the Sleeves. Place the sweater in a bucket of water (max. 30°C [86°F]) and leave it there until all the air is out of the sweater. Dry flat and stretch into shape. It is very important that you do not hang the sweater to dry, as this will make it stretch.

Chart A

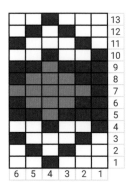

Chart B

Chart C (Yoke)

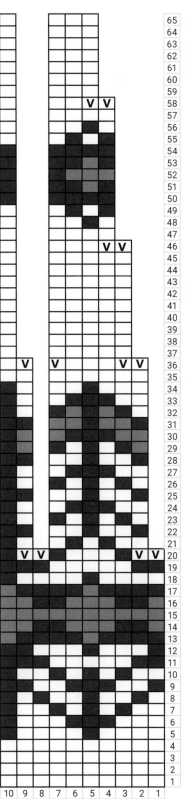

65 Finish for size XXL. See Neck in pattern.
64
63 Finish for sizes L, XL. See Neck in pattern.
62 Finish for size M. See Neck in pattern.
61 Finish for size S. See Neck in pattern.
60
59
58 Dec as shown = 120(132:148:156:164) sts
57
56
55
54
53
52
51
50
49
48
47
46 Dec as shown = 150(165:185:195:205) sts
45
44
43 Skip this round for sizes S, M, L
42 Skip this round for sizes S, M, L
41
40
39
38
37
36 Dec as shown = 180(198:222:234:246) sts
35
34
33
32
31
30
29
28
27
26
25
24
23
22
21
20 Dec as shown = 240(264:296:312:328) sts
19
18
17
16
15
14
13
12
11
10
9
8
7
6
5
4
3 Skip this round for sizes S, M
2 Adjust so there are 300(330:370:390:410) sts
1 302(328:374:392:412) sts

VV = Knit 2 stitches together (k2tog)
V = 1 stitch
M = stitch

73

Molinka

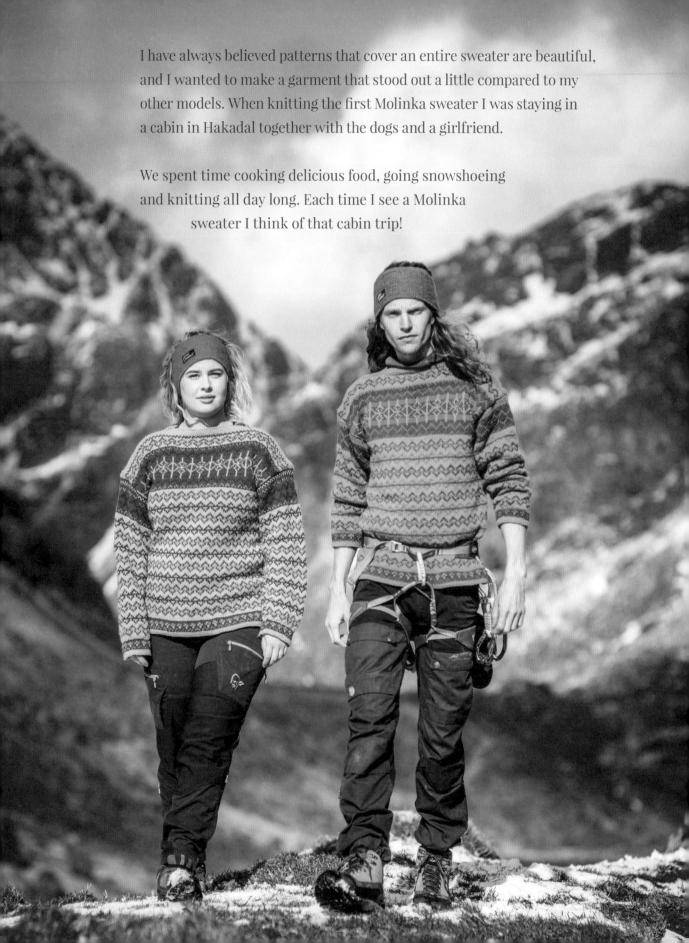

I have always believed patterns that cover an entire sweater are beautiful, and I wanted to make a garment that stood out a little compared to my other models. When knitting the first Molinka sweater I was staying in a cabin in Hakadal together with the dogs and a girlfriend.

We spent time cooking delicious food, going snowshoeing and knitting all day long. Each time I see a Molinka sweater I think of that cabin trip!

Molinka Sweater

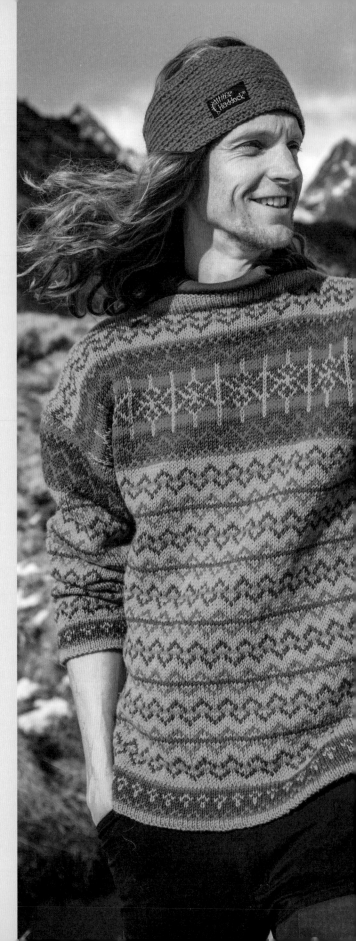

SIZES
S(M:L:XL:XXL)

TENSION (GAUGE)
10cm (4in) on 3.5mm (US 4) needle =22 sts

YARN
3-ply Strikkegarn from Rauma

AMOUNT OF YARN
Ochre (146): 350(400:450:500:550)g
(12¼[14:15¾:17½:19½]oz)
Dark Blue (184): 150(200:200:200:200)g
(5¼[7:7:7:7]oz)
Sea Green (175): 150(150:150:150:200)g
(5¼[5¼:5¼:5¼:7]oz)
Orange (177): 50g (1¾oz)

KNITTING NEEDLES
3mm & 3.5mm (US 2/3 & 4) double-pointed needles
3mm & 3.5mm (US 2/3 & 4) 40cm (16in) circular
needles
3mm & 3.5mm (US 2/3 & 4) 80cm (30in) circular
needles

MEASUREMENTS
For best fit, add 10cm (4in) to chest measurement.

Sleeves women: 47(48:49:50:51)cm
(18½[19:19¼:19¾:20]in)
Sleeves men: 52(53:54:55:56)cm
(20½[21:21¼:21¾:22]in)
 (or desired length)
Chest (unisex): 93(103:114:125:131)cm
(36½[40½:45:49½:51½]in)
Complete length women: 63(65:66:67:69)cm
(24¾[25½:26:26¼:27¼]in)
Complete length men: 67(68:70:72:74)cm
(26¼[26¾:27½:28¼:29¼]in)
(or desired length)

FRONT AND BACK PIECE
With 3mm (US 2/3) circular needle and Ocher, cast on 204(228:252:276:288) sts
and work st st in the round for 5cm (2in) for a folding edge. Work 1 round purl then
work Chart A. Fold over and sew the folding edge. Change to 3.5mm (US 4) needle
(if you knit tightly: go up one needle size when working charts) and repeat Chart B
until the piece measures 41(43:44:45:47)cm (16¼[17:17¼:17¾:18½]in) for women and
45(47:48:50:52)cm (17¾[18½:19:19¾:20½]in) for men. Place a marker in the beginning
of the round and after 102(114:126:138:144) sts (= front and back piece). Work Chart
C, purl 1 round and then knit for 2cm (¾in) for folding edge. Cast (bind) off and fold
over and sew folding edge. Set the work aside and knit Sleeves.

SLEEVES
With 3mm (US 2/3) double-pointed needles and Ocher, cast on 44(48:48:52:52) sts
and work 13 rounds st st for a folding edge. Work 1 round purl then work Chart A
(change needle size if necessary). Fold over and sew the folding edge.
With Ocher knit 1 round and at the same time change to 3.5mm (US 4) double-
pointed needles and inc the number of sts evenly to 60(64:64:68:68) sts. Mark the
middle st under the sleeve (beginning and end of round). This should be worked purl
at all times to easier keep track of where the round ends and begins. Inc 1 st on each
side of marked st every 2cm (¾in) until there are 96(104:104:104:106) sts (the pattern
does not apply to all sizes). Work Chart B and repeat it until the sleeve measures
38(39:40:41:42)cm (15[15¼:15¾:16¼:16½]in) for women and 43(44:45:46:47)cm
(17[17¼:17¾:18¼:18½]in) for men (or the desired length) then work Chart D. Turn the
sleeve and knit 5 rounds for the facing. Cast (bind) off. The facing will be used to sew
over the raw edge later. Knit the other sleeve in the same way.

ASSEMBLY
Weave in loose ends and steam the sweater lightly (use a damp cloth or similar in
between if you use an iron). Sew two tight machine seams corresponding to the width
of the sleeve. Stitch the shoulders together, but leave the middle 46(52:52:54:56) sts
from the front and back piece for the neck (total 92(104:104:108:112) sts for neck).
Cut between the seams. Sew in the Sleeves by hand or with a sewing machine.
Finish off by sewing the facing over the raw edge. There is an instructional video on
valleyknits.blog.

Rinse the sweater in water (max. 30°C [86°F]) and dry flat and stretch into shape. It is
very important that you do not hang the sweater to dry, as this will make it stretch.

Chart A

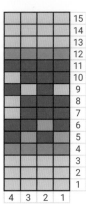

Chart B

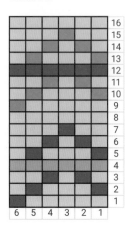

Chart C (Front and Back Piece)

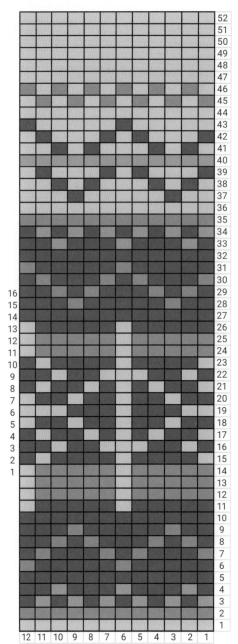

Chart D

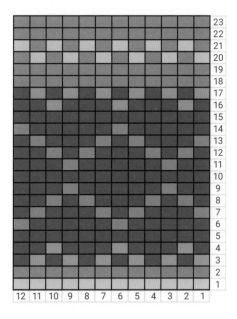

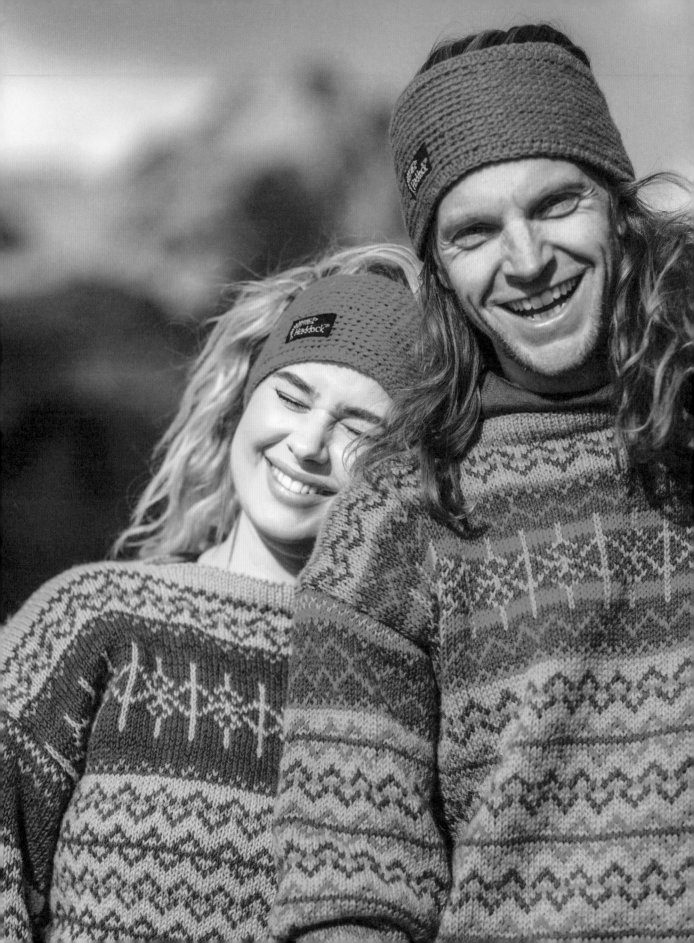

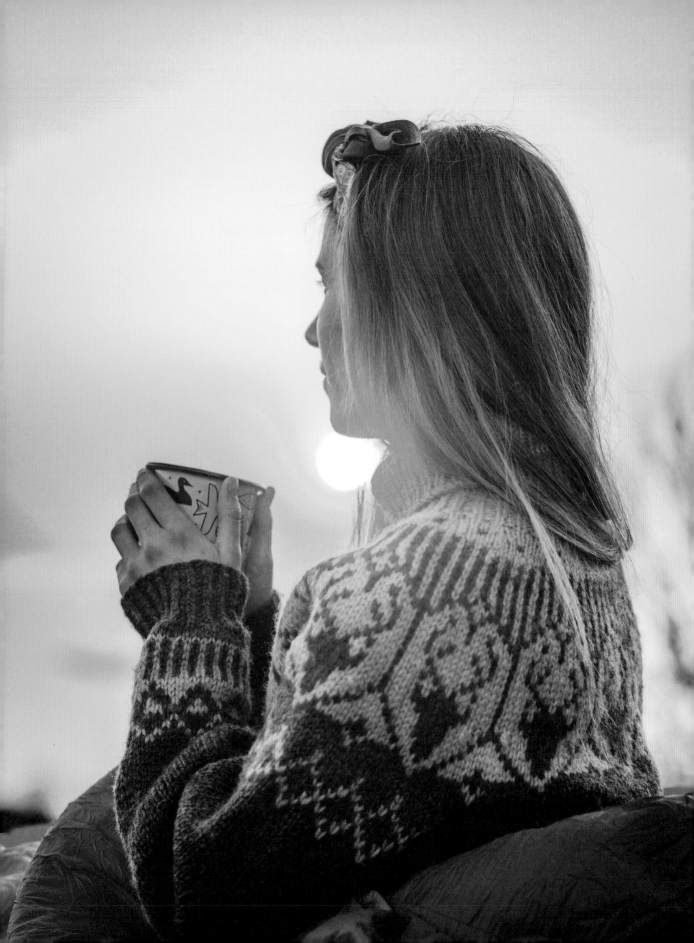

Nordkalotten

When I sat down on a cold autumn evening to draw the
Nordkalotten pattern, I was inspired by life in the North:
snow-covered landscape and reindeers fighting through the
long winters in extreme weathers. The Nordkalotten sweater
is a tribute to the reindeer – one of the most beautiful and
toughest animals we have in Norway.

Nordkalotten Sweater

SIZES
S(M:L:XL:XXL)

TENSION (GAUGE)
10cm (4in) on 6mm (US 10) needle = 14 sts

YARN
Vamsegarn from Rauma

AMOUNT OF YARN
Rust (401): 300(350:400:400:450)g
(10½[12¼:14:14:15¾]oz)
Navy Blue (077): 100g (3½oz)
Natural White (001): 200(200:200:250:250)g
(7[7:7:8¾:8¾]oz)

KNITTING NEEDLES
4.5mm & 6mm (US 7 & 10) double-pointed needles
4.5mm & 6mm (US 7 & 10) 40cm (16in) circular
needles
4.5mm & 6mm (US 7 & 10) 80cm (30in) circular
needles

MEASUREMENTS
Sleeves women: 48(49:50:51:52)cm
(19[19¼:19¾:20:20½]in)
Sleeves men: 53(54:55:56:57)cm
(21[21¼:21¾:22:22½]in)
Chest (unisex): 94(102:111:120:128)cm
(37[40¼:43¾:47¼:50½]in)
Body length women: 42(43:44:45:45)cm
(16½[17:17¼:17¾:17¾]in)
Body length men: 44(45:46:47:47)cm
(17¼[17¾:18¼:18½:18½]in)

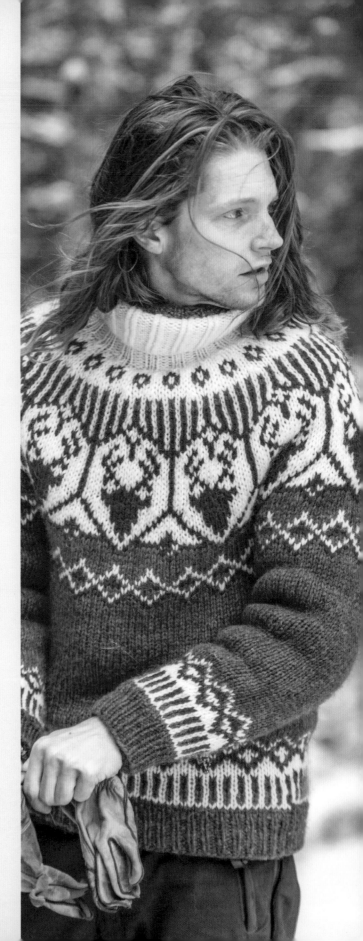

BODY

With 4.5mm (US 7) circular needle and Rust, cast on 132(144:156:168:180) sts and work k1, p1 rib for 6cm (2¼in). Place a marker at the beginning of the round. Change to 6mm (US 10) circular needle (cont in st st in the round) and work Chart A (if you knit tightly: go up one needle size when working charts). Cont in Rust until the piece measures 36(37:38:39:39)cm (14¼[14½:15:15¼:15¼]in) for women and 38(39:40:41:41)cm (15[15¼:15¾:16¼:16¼]in) for men. Work Chart B (change needle size if necessary). The body should now measure 42(43:44:45:45)cm (16½[17:17¼:17¾:17¾]in) for women and 44(45:46:47:47)cm (17¼[17¾:18¼:18½:18½]in) for men (or desired length).

Place a marker after 66(72:78:84:90) sts so that you have a marker in each side (= front and back piece). Place 9(7:9:7:6) sts from each side on scrap yarn or a stitch holder.

SLEEVES

With 4.5mm (US 7) double-pointed needles and Rust, cast on 38(38:40:40:40) sts and work k1, p1 rib for 6cm (2¼in). Change to 6mm (US 10) double-pointed needles (cont in st st) and inc 4(10:8:8:8) sts evenly across first round = 42(48:48:48:48) sts. Work Chart A (change needle size, if necessary) and cont in Rust. Mark the middle st under the sleeve and inc 1 st on each side of the marked st every 2(2.5:2.5:3:3)cm (¾[1:1:1¼:1¼]in) until there are 60(60:66:66:66) sts. Cont in Rust until the piece measures 42(43:44:45:46)cm (16½[17:17¼:17¾:18¼]in) for women and 47(48:49:50:51)cm (18½[19:19¼:19¾:20]in) for men and work Chart B (change needle size if necessary). The sleeve should now measure 48(49:50:51:52)cm (19[19¼:19¾:20:20½]in) for women and 53(54:55:56:57)cm (21[21¼:21¾:22:22½]in) for men (or desired length). Place 9(8:9:8:6) sts from the middle of the sleeve on scrap yarn or a stitch holder. Knit the other sleeve the same way.

YOKE

Knit the Sleeves onto same needle as the Body. Place a marker at the first join to mark the beginning and end of the round. You should now have 216(234:252:270:288) sts on the needle. Work Chart C for the yoke (change needle size, if necessary) and dec as shown in the chart. Note that not all the details in Chart B will line up parallel with the details in Chart C on the Sleeves and back.

NECK

Change to 4.5mm (US 7) needle and White, work k2, p2 rib for 20cm (8in) and cast (bind) off loosely in rib.

ASSEMBLY

Weave in loose ends and knit (or sew) together underneath the Sleeves. Rinse the sweater in water (max. 30°C [86°F]) and leave it there until all the air is out of the sweater. Dry flat and stretch into shape. It is very important that you do not hang the sweater to dry, as this will make it stretch.

Chart A
(Sleeves and Body)

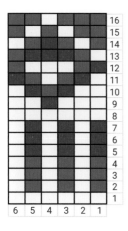

						16
						15
						14
						13
						12
						11
						10
						9
						8
						7
						6
						5
						4
						3
						2
						1
6	5	4	3	2	1	

Chart B
(Sleeves and Body)

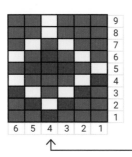

VV = Knit 2 stitches together (k2tog)
V = 1 stitch
M = stitch

4 = Centre front on sweater. Count from the middle where to begin knitting on the chart.

Chart C (Yoke)

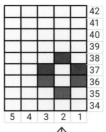

					42
					41
					40
					39
					38
					37
					36
					35
					34
5	4	3	2	1	

42 Dec 0(16:16:26:26) sts evenly for sizes M, L, XL, XXL = 84 sts
41 Finish for size S
40 Dec 34(20:30:30:40) sts evenly = 76(100:100:110:110) sts
39
38 Skip this round for sizes S, M, L
37 Skip this round for sizes S, M, L
36 Skip this round for sizes S, M, L
35
34 Dec 34(36:38:40:42) sts = 110(120:130:140:150) sts

2 = centre front on sweater.

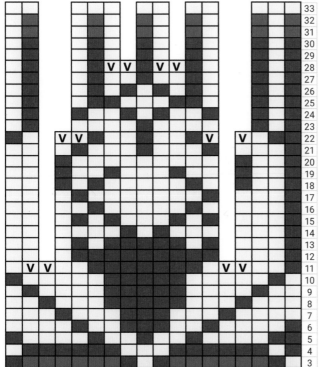

33
32
31
30 Skip this round for sizes S, M
29 Skip this round for sizes S, M
28 Dec as shown = 144(156:168:180:192) sts
27
26
25
24
23
22 Dec as shown = 168(182:196:210:224) sts
21
20 Skip this round for size S
19
18
17
16
15
14
13
12
11 Dec as shown = 192(208:224:240:256) sts
10
9
8
7
6
5
4
3
2
1 216(234:252:270:288) sts

18	17	16	15	14	13	12	11	10	9	8	7	6	5	4	3	2	1

10 = Centre front on sweater. Count from the middle where to begin knitting on the chart.

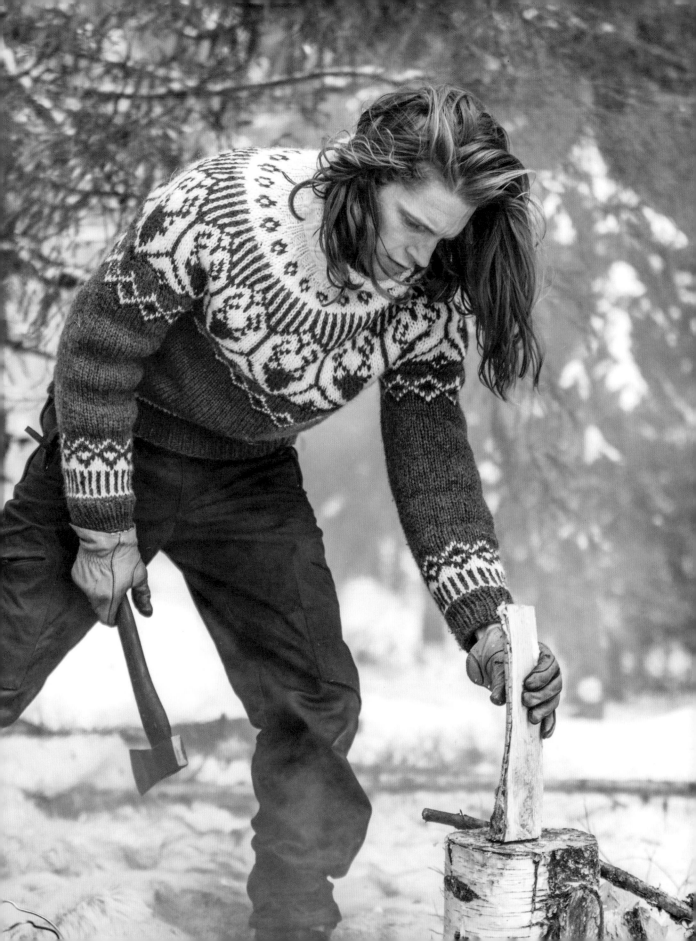

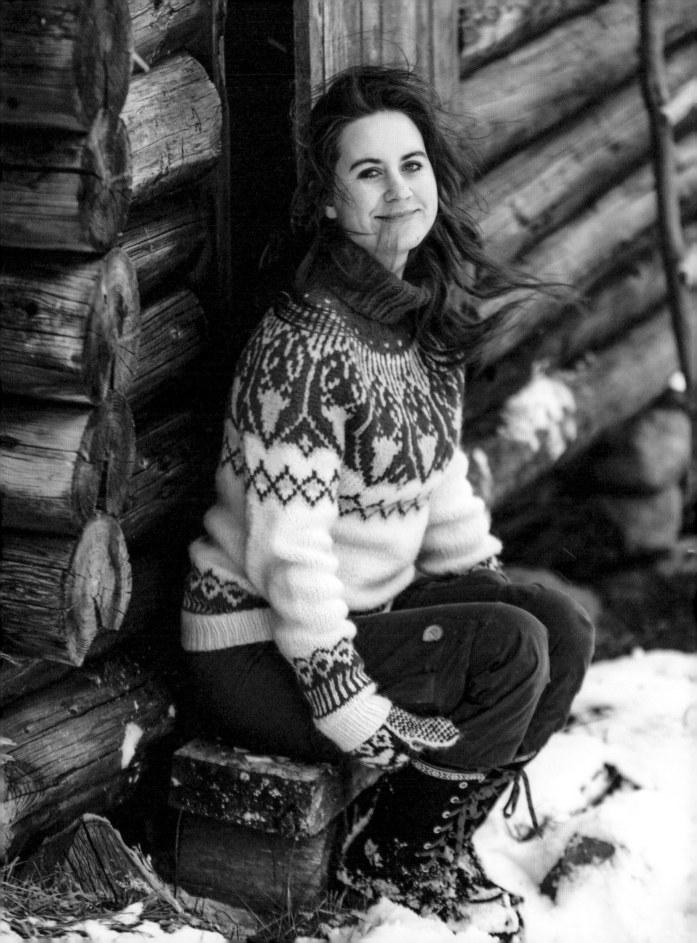

Nordkalotten Cardigan

SIZES
S(M:L:XL:XXL)

TENSION (GAUGE)
10cm (4in) on 3.5mm (US 4) needle = 22 sts

YARN
3-ply Strikkegarn from Rauma

AMOUNT OF YARN
Mottled Brown (164) = 450(500:550:600:650)g
(15¾[17½:19½21¼:23]oz)
Light Grey (103) = 100(100:100:150:150)g
(3½[3½:3½:5¼:5¼]oz)
Charcoal Grey (107) = 100g (3½oz)
Dark Red (128) = 100g (3½oz)

BUTTONS
7(7:8:8:8) 25mm (1in) buffalo horn buttons

KNITTING NEEDLES
3mm & 3.5mm (US 2/3 & 4) double-pointed needles
3mm & 3.5mm (US 2/3 & 4) 40cm (16in) circular
needles
3mm & 3.5mm (US 2/3 & 4) 80cm (30in) circular
needles

MEASUREMENTS
Sleeves women: 47(48:49:50:51)cm
(18½[19:19¼:19¾:20]in)
Sleeves men: 50(52:53:54:55)cm
(19¾[20½:21:21¼:21¾]in)
(or desired length)
Chest (unisex): 93(101:107:114:123)cm
(36½[39¾:42¼:45:48½]in)
Body length women: 40(42:43:44:44)cm
(15¾[16½:17:17¼:17¼]in
Body length men: 44(45:46:47:47)cm
(17¼[17¾:18¼:18½:18½]in)
(or desired length)

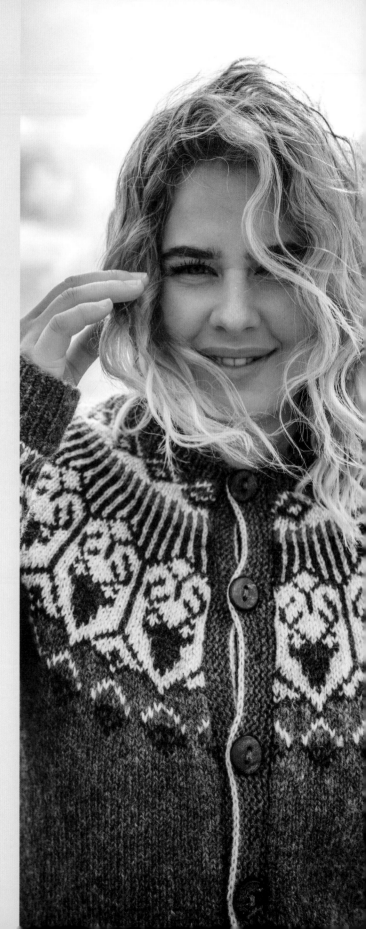

BODY

With 3mm (US 2/3) circular needle and Mottled Brown, cast on 199(217:229:247:265) sts and work k1, p1 rib back and forth for 6cm (2¼in). The first row is the wrong side, so purl the first st (it is important that the outer sts are knit for picking up Button Bands later). Cast on 5 sts on the right needle for steek stitches. These need to be constantly worked in purl (they are not included in the stitch count). Change to 3.5mm (US 4) circular needle (cont in st st in the round). Work Chart A (if you knit tightly: go up one needle size when working charts). The pattern is worked over 6 sts as shown in the chart + 1 st so that the pattern is symmetrical on both sides of the Button Bands (this also applies to the Yoke). Place markers so there are 101(109:115:123:133) sts for the back piece and on 49(54:57:62:66) sts for each front piece. Cont in st st until the piece measures 40(42:43:44:44)cm (15¾[16½:17:17¼:17¼]in) for women or 44(45:46:47:47)cm (17¼[17¾:18¼:18½:18½]in) for men. Place 11 sts from each side of body on scrap yarn or a stitch holder (the marked st and 5 sts on each side).
Put piece aside and knit Sleeves.

SLEEVES

With 3mm (US 2/3) double-pointed needles and Mottled Brown, cast on 42(48:48:54:54) sts and work k1, p1 rib in the round for 6cm (2¼in). Change to 3.5mm (US 4) double-pointed needles (cont in st st) and inc 6 sts evenly = 48(54:54:60:60) sts. Work Chart A (change needle size if necessary) then cont in Mottled Brown. Mark the middle st under the sleeve (beginning of the round) and inc 1 st on each side of marked st every 2cm (¾in) until there are 76(78:82:86:86) sts. Work until the sleeve measures 47(48:49:50:51) cm (18½[19:19¼:19¾:20]in) for women or 50(52:53:54:55)cm (19¾[20½:21:21¼:21¾]in) for men (or desired length). Place 11 sts under the sleeve on scrap yarn or a stitch holder (the marked st and 5 sts on each side).
Knit the other sleeve the same way.

YOKE

Knit the Sleeves onto same needle as the Body = 307(329:349:375:393) sts. Work Chart B (change needle size, if necessary) and dec as shown in chart.

Chart A

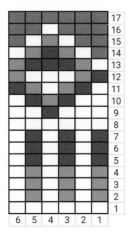

Chart B (Yoke)

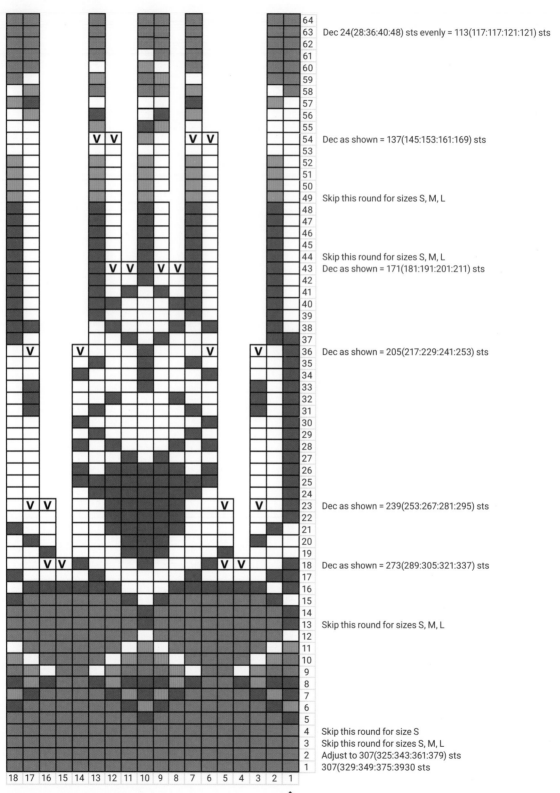

Row	Note
63	Dec 24(28:36:40:48) sts evenly = 113(117:117:121:121) sts
54	Dec as shown = 137(145:153:161:169) sts
49	Skip this round for sizes S, M, L
44	Skip this round for sizes S, M, L
43	Dec as shown = 171(181:191:201:211) sts
36	Dec as shown = 205(217:229:241:253) sts
23	Dec as shown = 239(253:267:281:295) sts
18	Dec as shown = 273(289:305:321:337) sts
13	Skip this round for sizes S, M, L
4	Skip this round for size S
3	Skip this round for sizes S, M, L
2	Adjust to 307(325:343:361:379) sts
1	307(329:349:375:3930 sts

↑ Begin here

VV = Knit 2 stitches together (k2tog)
V = 1 stitch
M = stitch

90

NECK

Finish off where specified for size. You should now have 113(117:117:121:121) sts on the needle (the steek stitches are not included in the stitch count). Cast (bind) off the steek sts and change to 3mm (US 2/3) needle. Work k1, p1 rib back and forth for 3cm (1¼in). Cast (bind) off in rib.

ASSEMBLY

Weave in loose ends and knit (or sew) together under the Sleeves. Sew two machine seams along the edges of the steek stitches. Sew three times to make sure the seam holds and the sts do not unravel. Cut between the two seams and work Button Bands.

Right Button Band

With 3mm (US 2/3) needle and Mottled Brown, pick up sts along right front piece. *Pick up 2 sts, skip 1 st,* rep from * to * to end. Work 3cm (1¼in) garter stitch. Cast (bind) off with Light Grey. Use yarn to sew on buttons after you have completed knitting both button bands.

Left Button Band

Work as for Right Button Band, but with 7(7:8:8:8) buttonholes evenly spaced after 1.5cm (½in). Place the lowest buttonhole approximately 2cm (¾in) from the bottom edge and the top approximately 1cm (½in) from the top edge. Work 1.5cm (½in) and cast (bind) off in knit with Light Grey.

Buttonholes

Cast (bind) off 2 sts, which you cast on again on the next row.

Facing

Pick up sts on the wrong side of the Button Bands (the first sts in the first row). Work 5 rows st st back and forth and sew the facing over the raw edge. Alternatively, sew on a ribbon over the raw edge.

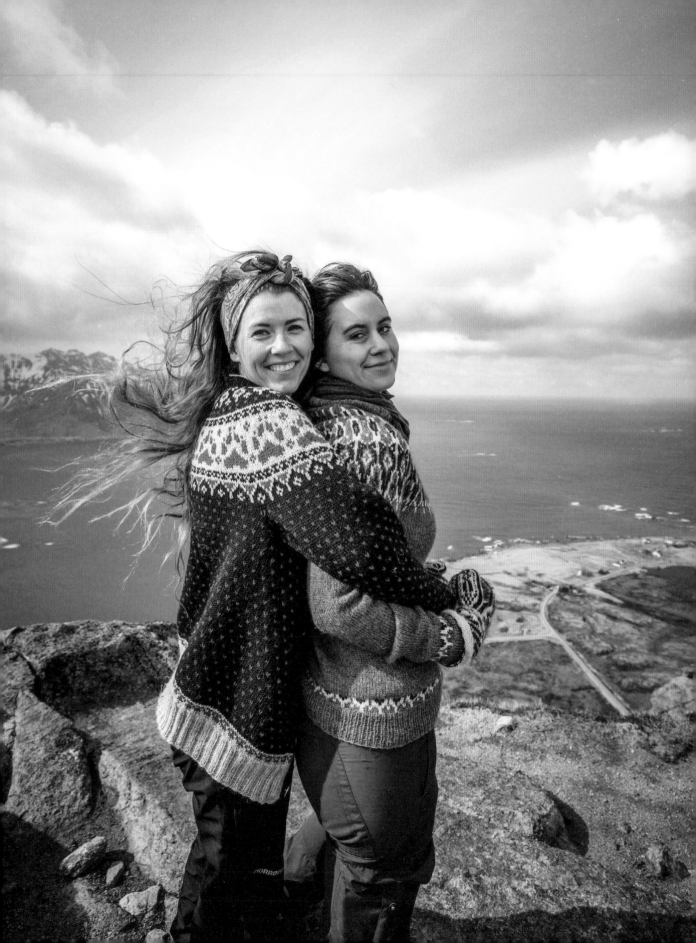

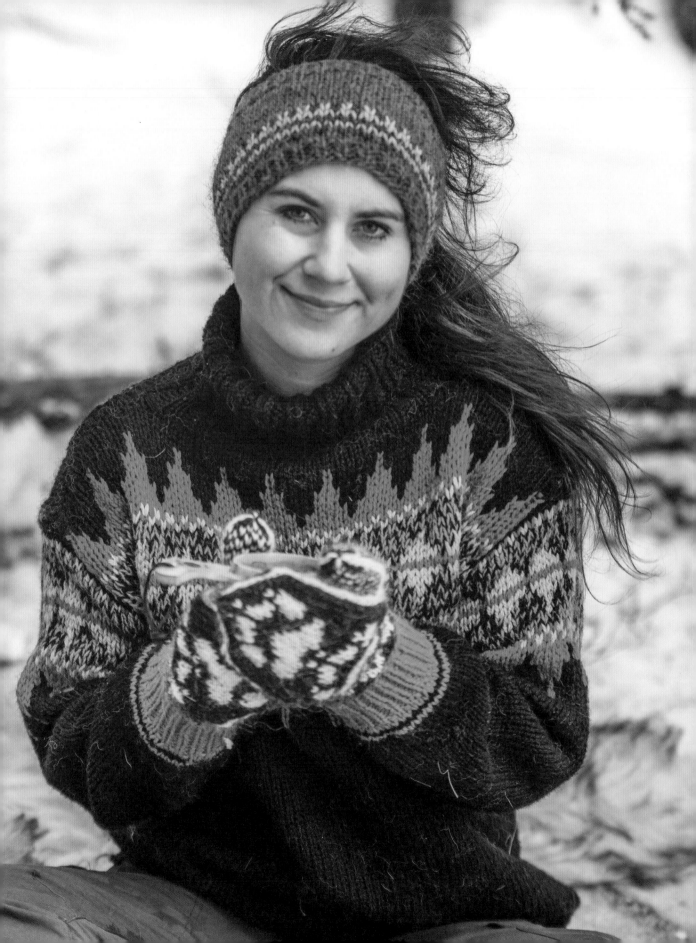

Norwegian Forest

The Norwegian Forest sweater is one of my absolute
favourites! When I started working on this sweater
I had not drawn the chart in advance. The result
became this sweater. My own Norwegian Forest
sweater is black, red, ochre and dark turquoise.
I practically live in that sweater!

Norwegian Forest Sweater

SIZES
S(M:L:XL:XXL)

TENSION (GAUGE)
10cm (4in) on 6mm (US 10) needle = 14 sts

YARN
Finull from Rauma. Knit with 2 strands held together.

AMOUNT OF YARN
Light Grey (0403) = 400(450:500:600:650)g
(14[15¾:17½:21¼:23]oz)
Ochre (4076) = 50(50:50:100:100)g
(1¾[1¾:1¾:3½:3½]oz)
Forest Green (0486) = 100g (3½oz)
Mole Brown (0464) = 50(50:100:100:100)g
(1¾[1¾:3½:3½:3½]oz)

KNITTING NEEDLES
4.5mm & 6mm (US 7 & 10) double-pointed needles
4.5mm & 6mm (US 7 & 10) 40cm (16in) circular needles
4.5mm & 6mm (US 7 & 10) 80cm (30in) circular needles

MEASUREMENTS
For best fit, measure your chest and add 10cm (4in) to get the right size.

Sleeves women: 49(50:51:52:53)cm
 (19¼[19¾:20:20½:21]in)
Sleeves men: 54(55:56:57:58)cm
(21¼[21¾:22:22½:22¾]in)
Chest (unisex): 94(102:111:120:128)cm
(37[40¼:43¾:47¼:50½]in)
Complete length women: 63(65:66:67:69)cm
(24¾[25½:26:26¼:27¼]in)
Complete length men: 67(69:70:72:74)cm
(26¼[27¼:27½:28¼:29¼]in)

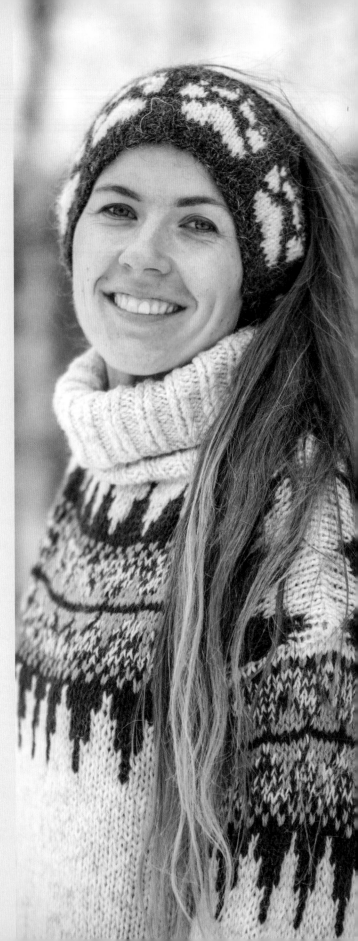

FRONT AND BACK PIECE
With 4.5mm (US 7) circular needle and Light Grey, cast on 132(144:156:168:180) sts and work k1, p1 rib for 6cm (2¼in). Change to 6mm (US 10) circular needle (cont in st st), and cont in Light Grey until front and back piece measures 39(41:42:43:45) cm (15¼[16¼:16½:17:17¾]in) for women and 43(45:46:48:50)cm (17[17¾:18¼:19:19¾] in) for men. Place markers so there are 66(72:78:84:90) sts for the front piece and 66(72:78:84:90) sts for the back piece. Work Chart A (if you knit tightly: go up one needle size when working charts). Set aside and knit Sleeves.

SLEEVES
With 4.5mm (US 7) double-pointed needles and Mole Brown, cast on 36(38:38:42:42) sts and work k1, p1 rib for 6cm (2¼in). Change to 6mm (US 10) double-pointed needles (cont in st st) and inc 6 sts evenly on first round = 42(44:44:48:48) sts. Work Chart B (change needle size if necessary). Place a marker around the middle st under the sleeve and inc 1 st on each side of the marked st every 2cm (¾in) until there are 60(60:66:72:72) sts. Cont in Light Grey until the sleeve measures 32(33:34:35:36)cm (12½[13:13½:13¾:14¼]in) for women and 37(38:39:40:41)cm (14½[15:15¼:15¾:16¼]in) for men, and work Chart C (change needle size if necessary). The sleeve should now measure 49(50:51:52:53)cm (19¼[19¾:20:20½:21]in) for women and 54(55:56:57:58) cm (21¼[21¾:22:22½:22¾]in) for men (or desired length). Turn the sleeve and knit 4 rounds for the facing. The facing should be sewn over the raw edge on the inside of the sweater during the assembly. Knit the other sleeve the same way.

ASSEMBLY
Weave in loose ends and steam the sweater lightly (use a damp cloth or similar in between if you use an iron).
Sew two tight machine seams corresponding to the width of the sleeve. Knit or stitch the shoulders together (place sts for the Neck on a spare needle – see below). Cut between the seams. Sew in the Sleeves by hand or with a sewing machine. Finish off by sewing the facing over the raw edge. There is an instructional video on valleyknits.blog.

NECK
Place the middle 37(37:39:39:41) sts from the front piece and the middle 37(37:39:39:41) sts from the back piece on 4.5mm (US 7) 40cm (16in) circular needle. Pick up 1 st from each shoulder to avoid holes where the neck meets the shoulders. You should now have 76(76:80:80:84) sts on the needle. With Light Grey, work k2, p2 rib for 20cm (8in) and cast (bind) off.

Rinse the sweater in cold water (max. 30°C [86°F]) and dry flat and stretch into shape. It is very important that you do not hang the sweater to dry, as this will make it stretch.

Chart A (Front and Back Piece)

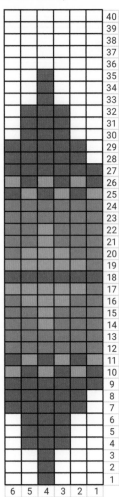

Chart B (Sleeves)

Chart C (Sleeves)

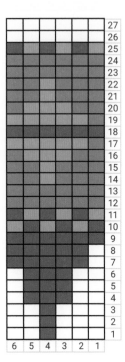

Double strand Mole Brown

Double strand Forest Green

Double strand Light Grey

Double strand Ochre

One strand each Light Grey and Mole Brown

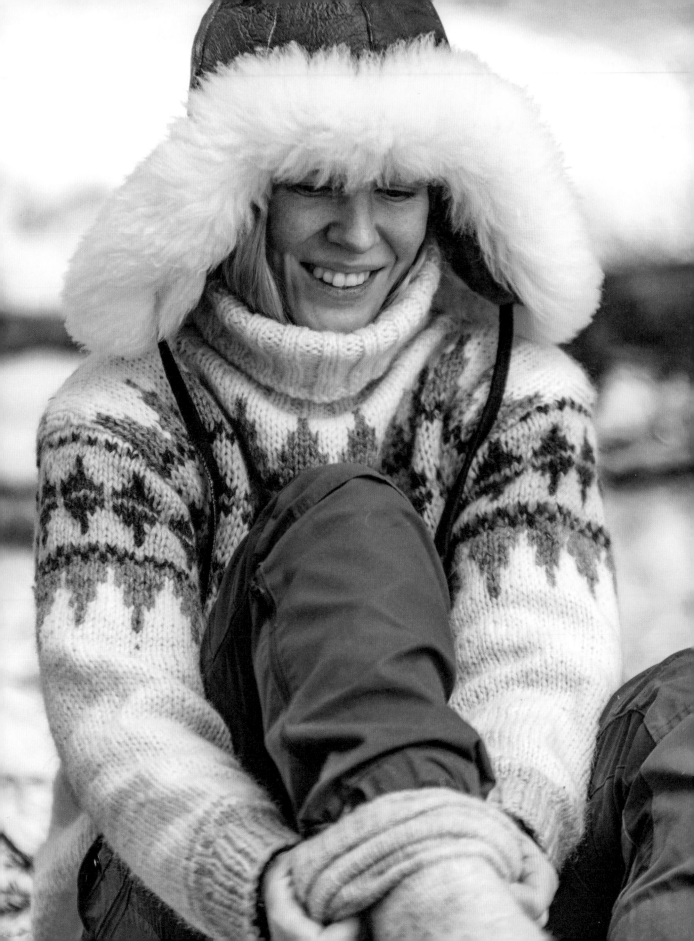

December Headband

SIZES
Women (men)
Circumference = 53(56)cm (21[22]in)
Height = 13(13)cm (5¼[5¼]in)

TENSION (GAUGE)
10cm (4in) on 6mm (US 10) needle =13 sts

YARN
Leftover Álafosslopi
Alternatives: Blåne or Troll from Hillesvåg Ullvarefabrikk

Cypress Green Heather (809966)
Arctic Exposure (801232)
Golden Heather (809964)
Burnt Orange (801236)
Light Beige Heather (800086)

KNITTING NEEDLES
4.5mm & 6mm (US 7 & 10) 50cm (19¾in)
circular needles

Cast on 70(74) sts on 4.5mm (US 7)
circular needle. Work the headband in
the round.
Work 3 rounds k1, p1 rib.
Change to 6mm (US 10) needle and work
chart.
Change to 4.5mm (US 7) needle and work
3 rounds k1, p1 rib and cast (bind) off in rib.
Weave in loose ends.

Chart

**You can find more knitwear at https://valleyknits.blog
or www.ravelry.com/designers/linka-karoline-neumann.**

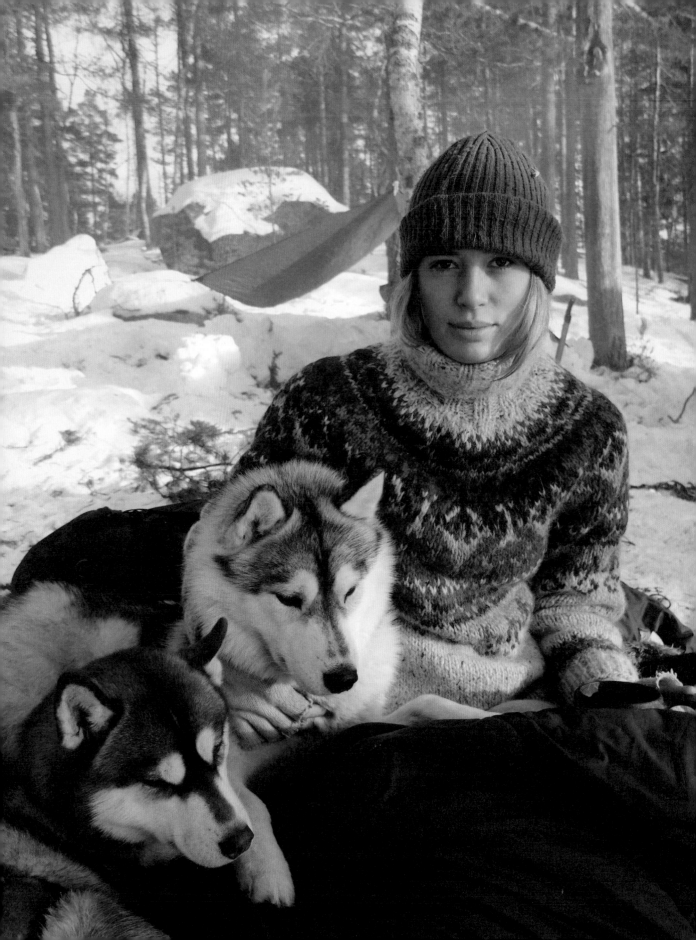

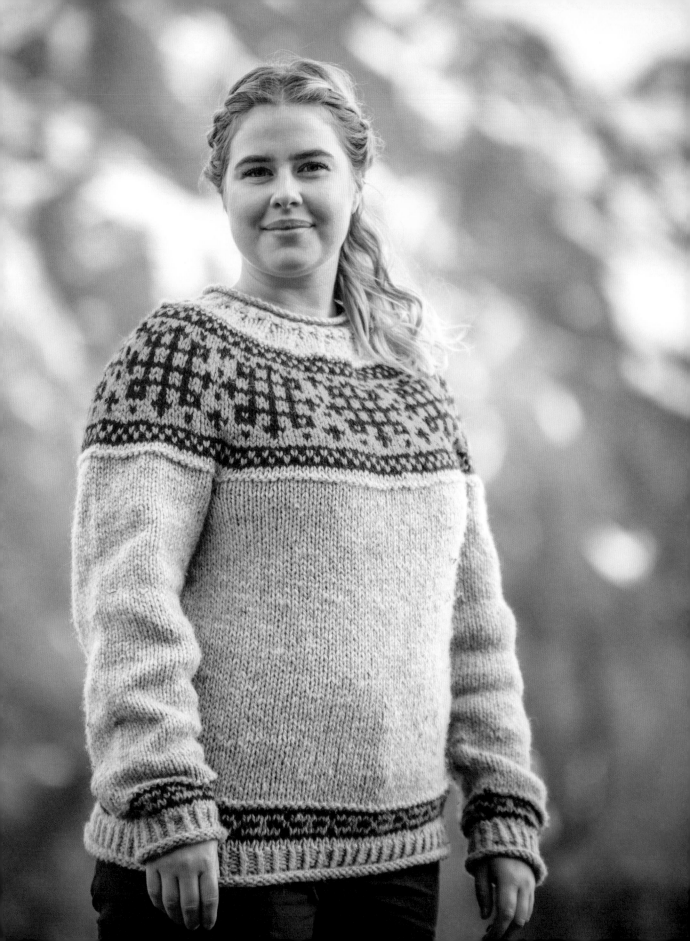

The Pilgrim Sweater

The Pilgrim Trail from Oslo to Trondheim goes straight past my home in Lommedalen. I feel a strong sense of belonging to this medieval road and I was drawn to design a Pilgrim sweater. In the summer of 2018, I met a girl from Switzerland who walked the Pilgrim Trail. I was so impressed with her project that I ran home and picked up my Pilgrim sweater, which I gave her as a memory from the trip. She was incredibly happy, and later I received a picture of her wearing the sweater in front of Nidaros Cathedral.

Pilgrim Sweater Polar

SIZES
S(M:L:XL:XXL)

TENSION (GAUGE)
10cm (4in) on 6mm (US 10) needle = 13 sts

YARN
Troll from Hillesvåg Ullvarefabrikk
Alternative:
Blåne from Hillesvåg Ullvarefabrikk

AMOUNT OF YARN
Low neck:
Troll Mottled, Light Brown (02705):
500(500:600:700:700)g (17½[17½:21¼:24½:24½]oz)
Troll Mottled, Orange (127011):
100(200:200:200:200)g (3½[7:7:7:7]oz)
Troll Dark Brown (02749):
100(100:200:200:200)g (3½[3½:7:7:7]oz)

High neck:
100g (3½oz) extra in the base colour

KNITTING NEEDLES
4.5mm & 6mm (US 7 & 10) double-pointed needles
4.5mm & 6mm (US 7 & 10) 40cm (16in) circular needles
4.5mm & 6mm (US 7 & 10) 80cm (30in) circular needles

MEASUREMENTS
Sleeves women: 47(48:49:50:51)cm (18½[19:19¼:19¾:20]in)
Sleeves men: 50(51:52:53:54)cm (19¾[20:20½:21:21¼]in)
Chest (unisex): 93(101:110:120:129)cm (36½[39¾:43¼:47¼:50¾]in)
Body length women: 41(42:43:44:45)cm (16¼[16½:17:17¼:17¾]in)
Body length men: 43(44:45:46:47)cm (17[17¼:17¾:18¼:18½]in)

BODY

With 4.5mm (US 7) circular needle and Light Brown, cast on 120(132:144:156:168) sts. Knit 5 rounds for a rolled edge then k1, p1 rib for 7 rounds. Place a marker at the beginning of the round. Change to 6mm (US 10) needle (cont in st st) and work Chart A (if you work tightly: go up one needle size when working charts). Cont in Light Brown until the piece measures 41(42:43:44:45)cm (16¼[16½:17:17¼:17¾]in) for women and 43(44:45:46:47)cm (17[17¼:17¾:18¼:18½]in) for men (or desired length). Place a marker after 60(66:72:78:84) sts so that you have a marker in each side (= front and back piece). Place 7(9:10:11:12) sts from each side on a scrap yarn or a stitch holder. Set the work aside and knit Sleeves.

SLEEVES

With 4.5mm (US 7) double-pointed needles and Light Brown, cast on 30(30:30:36:36) sts. Knit 5 rounds for a rolled edge then work 7 rounds k1, p1 rib. Change to 6mm (US 10) needle (cont in st st) while at the same time inc 6 sts evenly on the first round = 36(36:36:42:42) sts. Work Chart A (change needle size if necessary). Cont in Light Brown. Place a marker around the middle st under the sleeve and inc 1 st in each side of the marked st every 7th round until there are 52(54:56:60:62) sts. Work until the sleeve measures 47(48:49:50:51)cm (18½[19:19¼:19¾:20]in) for women and 50(51:52:53:54)cm (19¾[20:20½:21:21¼]in) for men (or desired length). Place 6(9:10:10:11) sts from the middle of the sleeve on scrap yarn or a stitch holder. Knit the other sleeve the same way.

YOKE

Knit the Sleeves onto same needle as the Body. Place a marker at the first join to mark the beginning and end of the round. You should now have 198(204:216:234:246) sts on the needle. Work Chart B (change needle size if necessary) for the yoke and dec as shown.

Low neck

Change to 4.5mm (US 7) needle and work k1, p1 rib for 2cm (¾in). Knit 5 rounds for rolled edge and cast (bind) off.

High neck

Work to the round specified on the chart. After adjusting the number of sts as shown in the chart, change to 4.5mm (US 7) needle and work k2, p2 rib for 20cm (8in) (or desired length). Cast (bind) off loosely.

ASSEMBLY

Weave in loose ends and knit (or sew) together underneath the Sleeves. Rinse the sweater in water (max. 30°C [86°F]) and leave it there until all the air is out of the sweater. Dry flat and stretch into shape. It is very important that you do not hang the sweater to dry, as this will make it stretch.

Chart A

This round is worked in purl

VV= Knit 2 stitches together (k2tog)
V = 1 stitch
M = stitch
U = purl stitch

Chart B

Row	Instruction
43	Inc 6(4:2:0:0) sts for high neck = 72(76:80:84:84) sts
42	Finish the chart here for low neck
41	Skip this round for sizes S, M, L, XL
40	Skip this round for sizes S, M, L
39	Dec as shown = 66(72:78:84:84) sts
38	Skip this round for sizes S, M
37	
36	Dec as shown = 88(96:104:112:112) sts
35	Skip this round for sizes S, M
34	
33	Dec as shown = 110(120:130:140:140) sts
32	Dec 1 st for sizes XL, XXL = 168 sts. Skip this round for sizes S, M, L
31	This round is worked in purl
30	Inc 2(1:0:0:0) sts

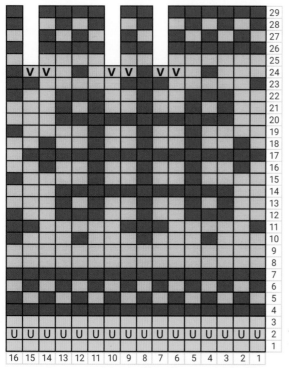

Row	Instruction
24	Dec as shown = 130(143:156:169:169) sts
9	Dec 38(28:24:26:38) sts evenly = 160(176:192:208:208) sts
2	This round is worked in purl
1	198(204:216:234:246) sts

↑_____ 8 = Centre front on sweater. Count from the
middle where to begin knitting on the chart.

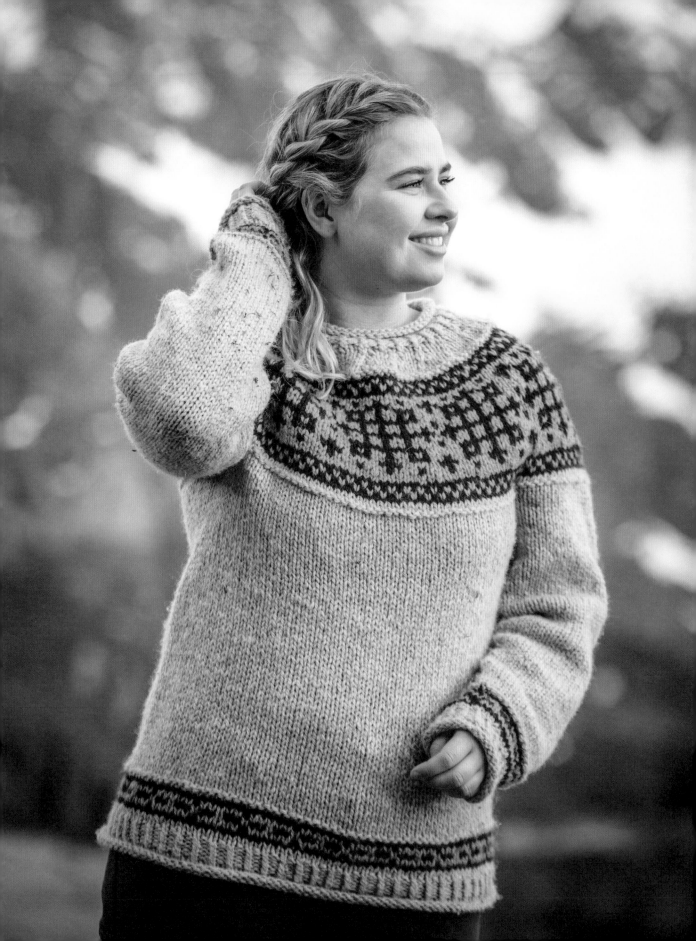

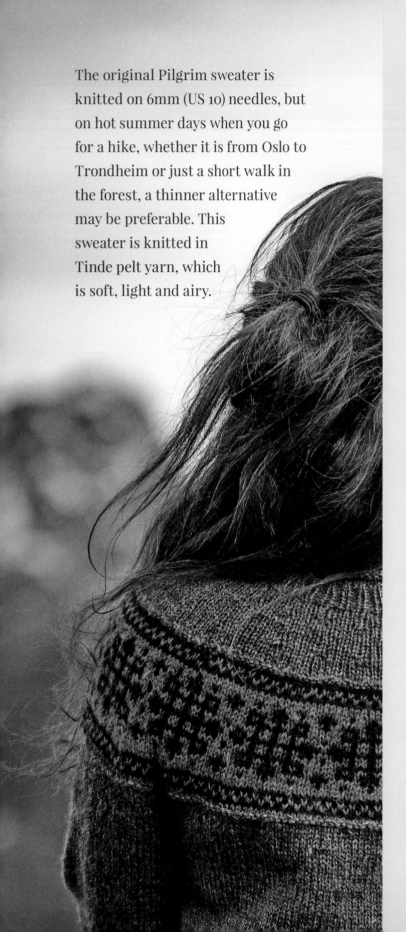

The original Pilgrim sweater is knitted on 6mm (US 10) needles, but on hot summer days when you go for a hike, whether it is from Oslo to Trondheim or just a short walk in the forest, a thinner alternative may be preferable. This sweater is knitted in Tinde pelt yarn, which is soft, light and airy.

Pilgrim Sweater Thin

SIZES
S(M:L:XL:XXL)

TENSION (GAUGE)
10cm (4in) on 3.5mm (US 4) needle = 22 sts

YARN
Tinde from Hillesvåg Ullvarefabrikk

AMOUNT OF YARN
Low neck:
Light Brown (652102) = 400(500:500:500:600)g (14[17½:17½:17½:20¼]oz)
Light Turquoise (652130) = 100g (3½oz)
Dark Brown (652116) = 100g (3½oz)

High neck:
100g (3½oz) extra in the base colour

KNITTING NEEDLES
3mm & 3.5mm (US 2/3 & 4) double-pointed needles
3mm & 3.5mm (US 2/3 & 4) 40cm (16in) circular needles
3mm & 3.5mm (US 2/3 & 4) 80cm (30in) circular needles

MEASUREMENTS
Sleeves women: 47(48:49:50:51)cm (18½[19:19¼:19¾:20]in)
Sleeves men: 50(52:53:54:55)cm (19¾[20½:21:21¼:21¾]in)
Chest (unisex): 90(100:109:117:123)cm (35½[39½:43:46:48½]in)
Body length women: 40(42:43:44:44)cm (15¾[16½:17:17¼:17¼]in)
Body length men: 44(45:46:47:47)cm (17¼[17¾:18¼:18½:18½]in)

BODY

With 3mm (US 2/3) circular needle and Light Brown, cast on 198(222:240:258:270) sts. Knit 6 rounds for rolled edge then work k1, p1 rib for 4cm (1½in). Change to 3.5mm (US 4) needle (cont in st st in the round) and work Chart A (if you knit tightly: go up one needle size when working charts). Place a marker in each side with 99(111:120:129:135) sts for the front piece and 99(111:120:129:135) sts for the back piece. Cont in Light Brown until the piece measures 40(42:43:44:44)cm (15¾[16½:17:17¼:17¼]in) for women and 44(45:46:47:47)cm (17¼[17¾:18¼:18½:18½] in) for men (or desired length). Place 11 sts from each side on scrap yarn or a stitch holder (the marked st and 5 sts on each side).
Set the work aside and knit Sleeves.

SLEEVES

With 3mm (US 2/3) double-pointed needles and Light Brown, cast on 40(44:44:44:48) sts. Knit 6 rounds for rolled edge then work k1, p1 rib for 4cm (1½in). Change to 3.5mm (US 4) double-pointed needles (cont in st st) and inc the number of sts evenly to 48(54:54:60:60) sts. Work Chart A (change needle size if necessary). Place a marker around the middle st under the sleeve (the beginning of round). Inc 1 st on each side of the marked st every 2cm (¾in) until there are 74(78:82:82:86) sts. Work until the sleeve measures 47(48:49:50:51)cm (18½[19:19¼:19¾:20]in) for women and 50(52:53:54:55)cm (19¾[20½:21:21¼:21¾]in) for men (or desired length). Place 11 sts from under the sleeve on scrap yarn or a stitch holder (the marked st and 5 sts on each side). Set the work aside and knit the other sleeve the same way.

YOKE

Knit the Sleeves onto same needle as the Body = 302(334:360:378:398) sts and work Chart B (change needle size if necessary). Dec as shown in the chart and finish off where specified for size.

NECK

Low neck: Finish off where specified for size. You should now have 120(132:140:148:156) sts on the needle. With Light Brown, work in the round while at the same time dec evenly to 112(116:116:120:120) sts. Change to 3mm (US 2/3) needle and work k1, p1 rib for 3cm (1¼in). Knit 6 rounds for rolled edge. Cast (bind) off.

High neck: Finish off where specified for size. You should now have 120(132:140:148:156) sts on the needle. Work 1 round in Light Brown while at the same time dec evenly to 112(116:116:120:120) sts. Change to 3mm (US 2/3) needle and work k2, p2 rib for 20cm (8in). Cast (bind) off loosely.

ASSEMBLY

Weave in ends and knit (or sew) together under the Sleeves. Place the sweater in a bucket of cold water (max. 30°C [86°F]) and leave it there until all the air is out of the sweater. Stretch into shape and let it dry flat. It is very important that you do not hang the sweater to dry, as this will make it stretch.

Chart A

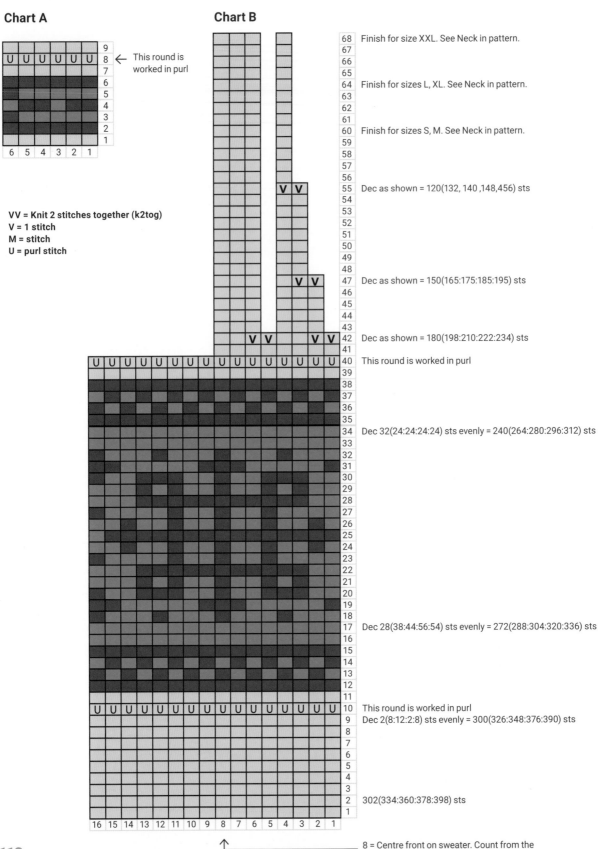

← This round is worked in purl

VV = Knit 2 stitches together (k2tog)
V = 1 stitch
M = stitch
U = purl stitch

Chart B

68 Finish for size XXL. See Neck in pattern.
67
66
65
64 Finish for sizes L, XL. See Neck in pattern.
63
62
61
60 Finish for sizes S, M. See Neck in pattern.
59
58
57
56
55 Dec as shown = 120(132, 140 ,148,456) sts
54
53
52
51
50
49
48
47 Dec as shown = 150(165:175:185:195) sts
46
45
44
43
42 Dec as shown = 180(198:210:222:234) sts
41
40 This round is worked in purl
39
38
37
36
35
34 Dec 32(24:24:24:24) sts evenly = 240(264:280:296:312) sts
33
32
31
30
29
28
27
26
25
24
23
22
21
20
19
18
17 Dec 28(38:44:56:54) sts evenly = 272(288:304:320:336) sts
16
15
14
13
12
11
10 This round is worked in purl
9 Dec 2(8:12:2:8) sts evenly = 300(326:348:376:390) sts
8
7
6
5
4
3
2 302(334:360:378:398) sts
1

8 = Centre front on sweater. Count from the middle where to begin knitting on the chart.

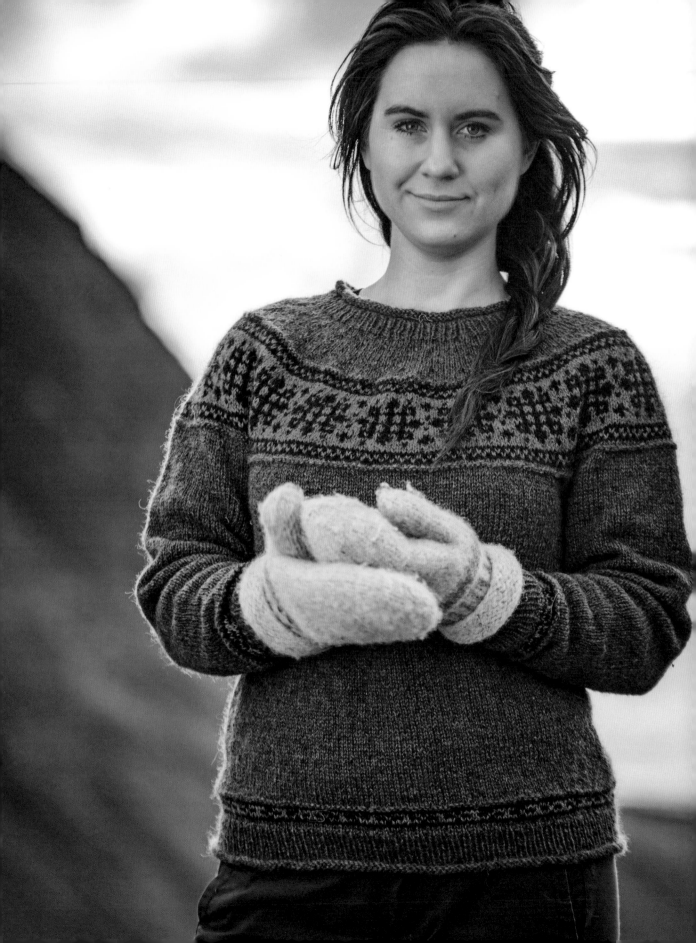

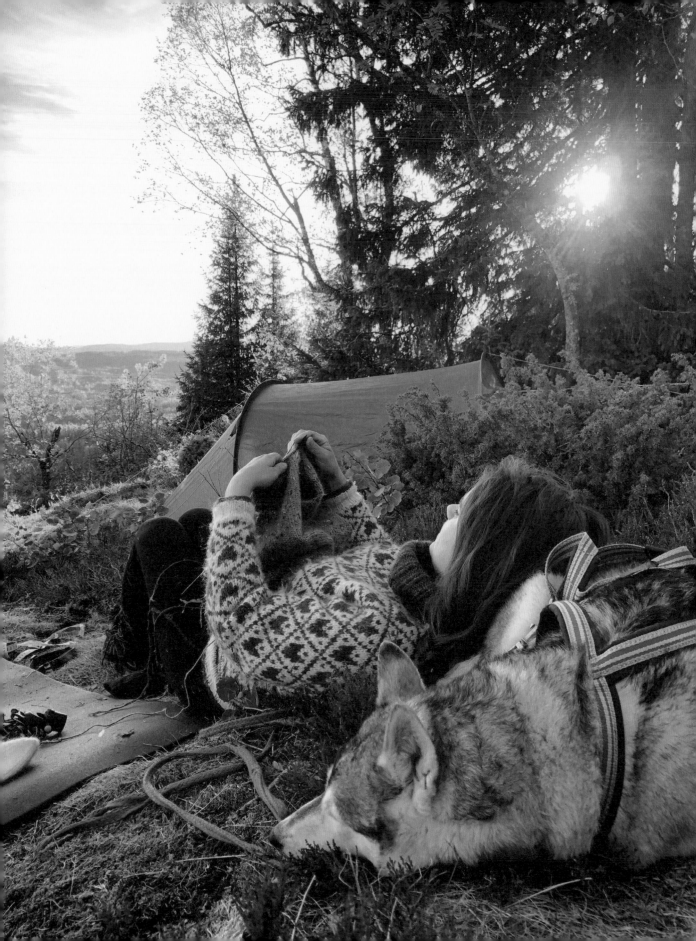

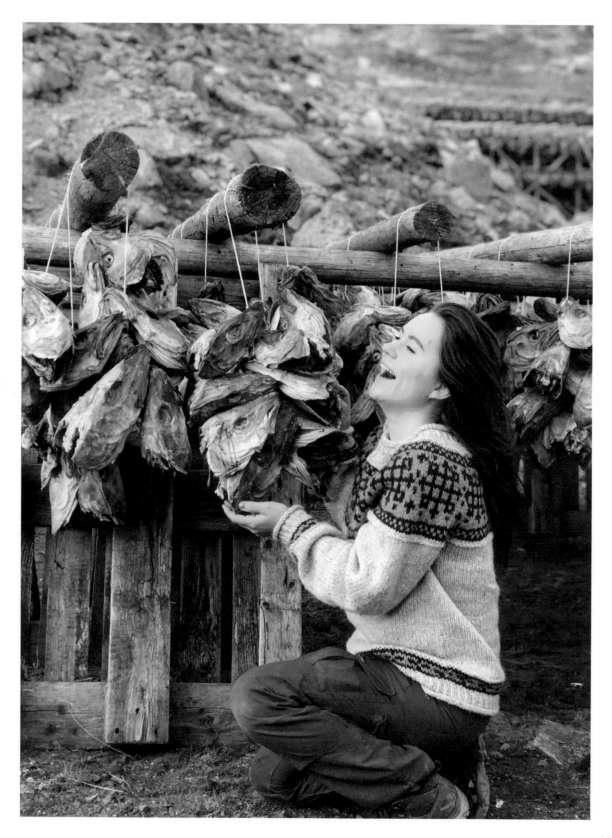

Storm Sweater

As the colourful person I am, I do not often knit solid coloured garments. To challenge myself, I decided to make a simpler sweater. The Storm sweater is knitted in two strands of Sølje pelt yarn, a shiny, soft and airy yarn in beautiful colours.

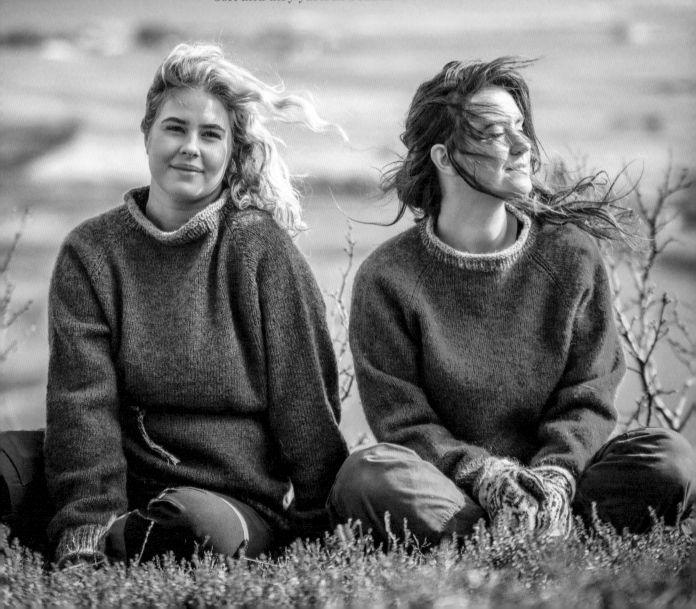

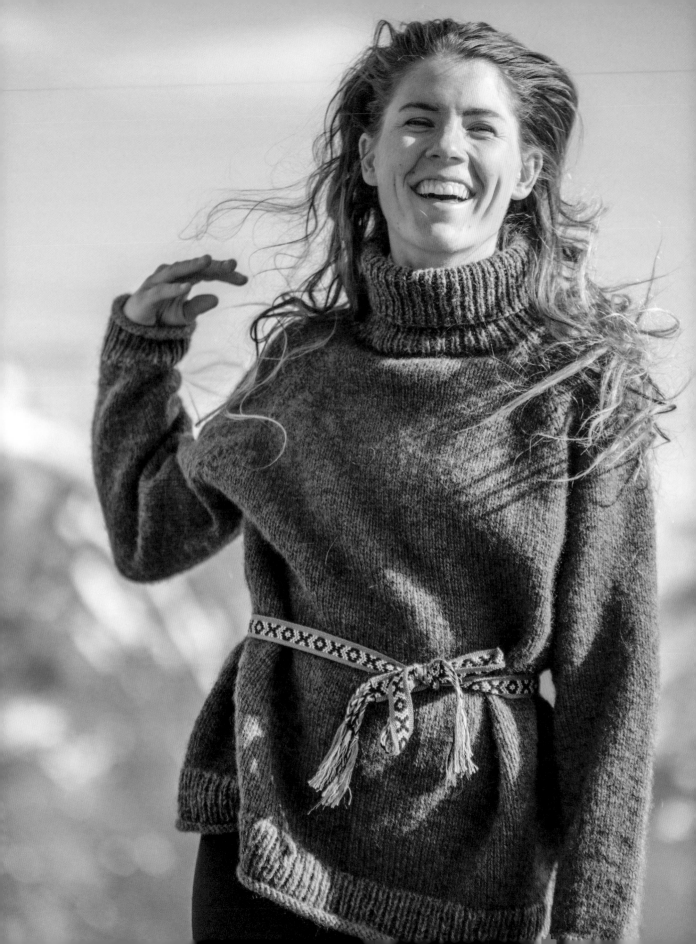

Storm Sweater

SIZES
S(M:L:XL:XXL)

TENSION (GAUGE)
10cm (4in) on 4.5mm (US 7) needle = 18 sts

YARN
Sølje from Hillesvåg Ullvarefabrikk
Knit with two strands.

AMOUNT OF YARN
Red (642132): 500(500:600:600:700)g
(17½[17½:21¼:21¼:24½]oz)
Light Reddish Beige (642136): 100g (3½oz)

KNITTING NEEDLES
4mm & 4.5mm (US 6 & 7) double-pointed needles
4mm & 4.5mm (US 6 & 7) 40cm (16in) circular
needles
4mm & 4.5mm (US 6 & 7) 80cm (30in) circular
needles

MEASUREMENTS
Sleeves women: 47cm (18½in)
Sleeves men: 55cm (21¾in)
Chest (unisex): 93(102:111:120:130)cm
(36½[40¼:43¾:47¼:51¼]in)
Body length women: 42cm (16½in)
Body length men: 46cm (18¼in)
(or desired length)

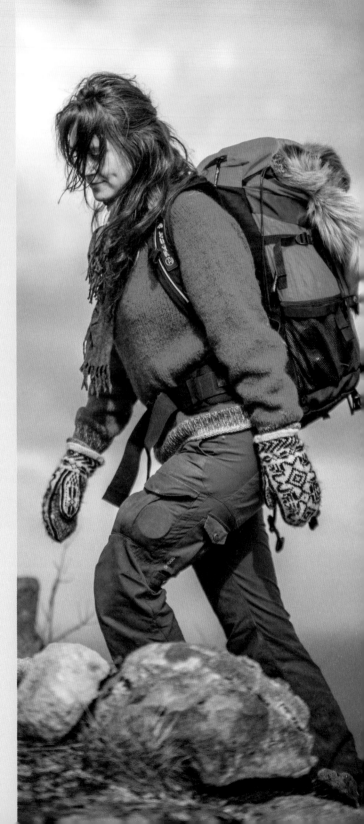

BODY

With 4mm (US 6) needle and Light Reddish Beige held double, cast on 168(184:200:216:234) sts. Knit 6 rounds for a rolled edge. With one strand Red and one strand Light Reddish Beige held together, work k1, p1 rib for 6(6:6:7:7)cm (2¼[2¼:2¼:2¾:2¾]in) . Change to 4.5mm (US 7) needle and cont in st st with Red held double. Work st st until the piece measures 42cm (16½in) for women or 46cm (18¼in) for men (or desired length). Place a marker in each side with 84(92:100:108:117) sts for front and 84(92:100:108:117) sts for back. Place 11 sts from each side on scrap yarn or a stitch holder (the marked st and 5 sts on each side).

SLEEVES

With 4mm (US 6) double-pointed needles and Light Reddish Beige held double, cast on 40(40:44:44:44) sts. Knit 6 rounds for a rolled edge. With one strand Red and one strand Light Reddish Beige held together, work k1, p1 rib for 5(5:6:7:7) cm (2[2:2¼:2¾:2¾]in). Change to 4.5mm (US 7) needle (cont in st st) and inc 8(8:12:12:12) sts evenly = 48(48:56:56:56) sts. From here, cont in Red held double. Place marker around the middle st under the sleeve (beginning of round) and inc 1 st on each side of the marked st every 8th round until there are 68(72:72:78:82) sts. Cont until the sleeve measures 47cm (18½in) for women and 55cm (21¾in) for men (or desired length). Place 11 sts from under the sleeve on scrap yarn or a stitch holder (the marked st and 5 sts on each side). Knit the other sleeve the same way.

YOKE, RAGLAN DECREASE

Knit the Sleeves onto same needle as the Body = 260(284:300:328:354) sts. Place a marker at to each join (the st where the Sleeve meets the Body) = a total of 4 sts marked. Knit 10(8:8:8:8) rounds before dec.

Raglan: Dec on each side of the marked sts. On the right of the marked st, dec to the left by knitting 2 sts together through the back loops. On the left of the marked stitch, dec to the right by knitting 2 sts together.
Dec every other round until you have a total of 84(84:92:96:98) sts on the needle.

Low neck: Change to 4mm (US 6) circular needle and adjust the number of sts to 84(84:92:96:96). With one strand Red and one strand Light Reddish Beige held together, work k1, p1 rib for 3cm (1¼in). With Light Reddish Beige held double, knit for 4 rounds for a rolled edge. Cast (bind) off loosely.

High neck: Change to 4mm (US 6) circular needle and adjust the number of sts to 84(84:92:96:96). With one strand Red and one strand Light Reddish Beige held together, work k1, p1 rib for 20cm (8in) rib. Cast (bind) off loosely.

ASSEMBLY

Weave in loose ends and knit (or sew) together under the Sleeves. Place the sweater in a bucket of water (max. 30°C [86°F]) and leave it there until all the air is out of the sweater. Stretch into shape and dry flat. It is very important that you do not hang the sweater to dry, as this will make it stretch.

Black wolf

Black wolf is one of the very
first sweaters I designed. This
is a tough and warm sweater
knitted in the soft Vamsegarn
from Rauma, which is available
in many colours.

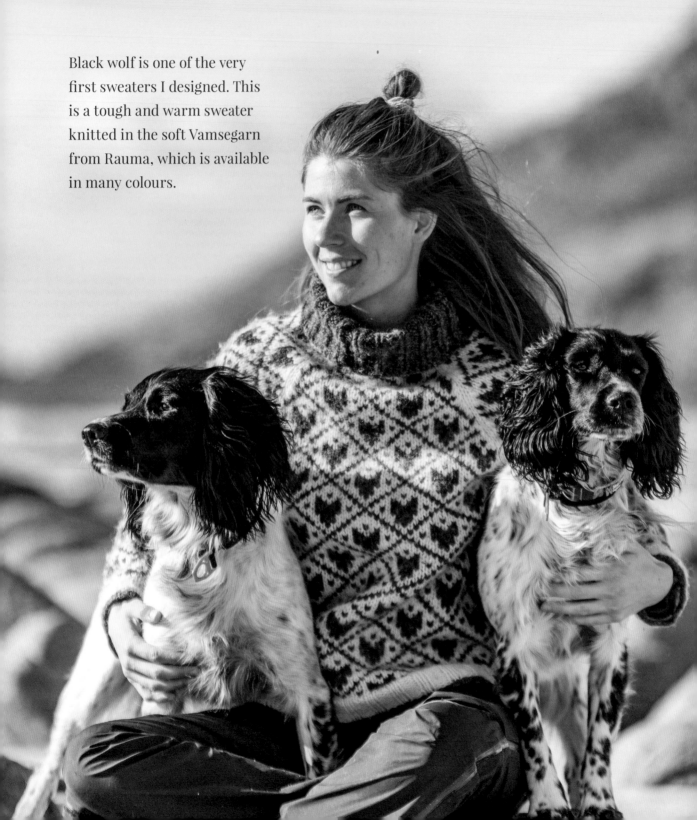

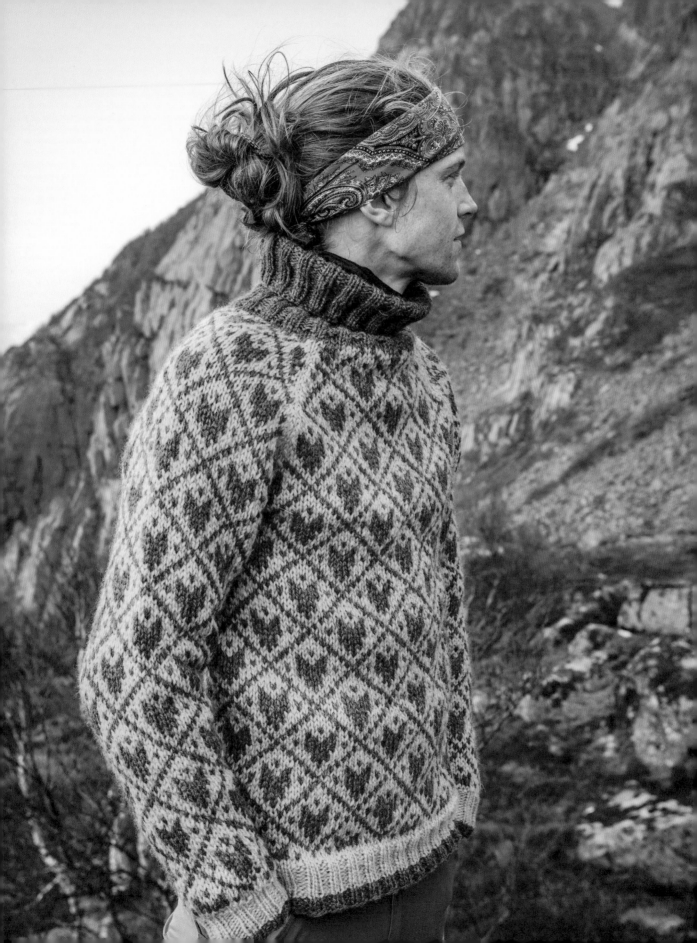

Black Wolf Sweater

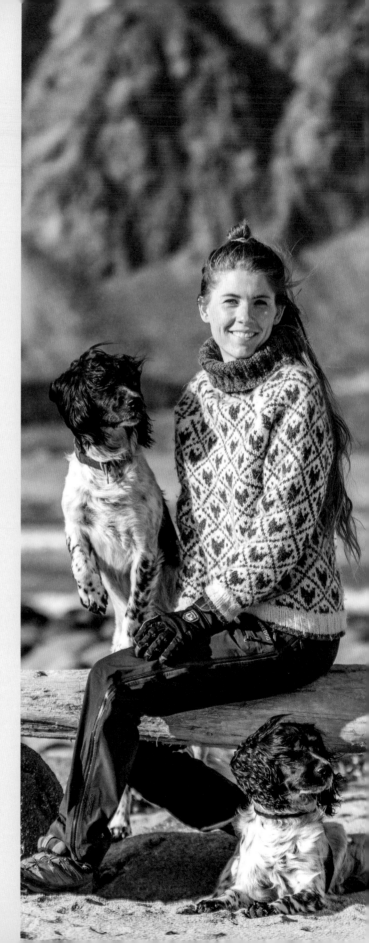

SIZES
S(M:L:XL:XXL)

TENSION (GAUGE)
10cm (4in) on 6mm (US 10) needle = 15 sts

YARN
Vamsegarn from Rauma

AMOUNT OF YARN
Charcoal Grey (14): 300(300:350:350:400)g
(10½[10½:12¼:12¼:10]oz)
Natural White (01): 300(300:350:450:450)g
(10½[10½:12¼:15¾:15¾]oz)

KNITTING NEEDLES
4.5mm & 6mm (US 7 & 10) double-pointed needles
4.5mm & 6mm (US 7 & 10) 40cm (16in) circular
needles
4.5mm & 6mm (US 7 & 10) 80cm (30in) circular
needles

MEASUREMENTS
Sleeves women: 47cm (18½in)
Sleeves men: 53cm (21in)
Chest (unisex): 93(102:111:121:130)cm
(36½[40¼:43¾:47¾:51¼]in)
Body length women: 42(42:43:43:44)cm
(16½[16½:17:17:17¼]in)
Body length men: 43(44:45:46:47)cm
(17[17¼:17¾:18¼:18½]in)

BODY

With 4.5mm (US 7) needle and Charcoal Grey, cast on 140(152:168:180:196) sts and work 3 rounds k2, p2 rib. Change to Natural White and knit 1 round. Cont in k2, p2 rib until the piece measures 7cm (2¾in). Change to 6mm (US 10) circular needle (cont in st st in the round) and inc 0(2:0:2:0) sts evenly = 140(154:168:182:196) sts. Place a marker at the beginning of the round and after 70(77:84:91:98) sts = front and back piece. Work chart. Repeat chart until the piece measures 42(42:43:43:44)cm (16½[16½:17:17:17¼]in) for women and 43(44:45:46:47)cm (17[17¼:17¾:18¼:18½]in) for men (or desired length). Place 8(8:8:10:10) sts from each side of the body on scrap yarn or a stitch holder (marked st and 4[4:4:5:5] sts on each side).

SLEEVES

With size 4.5mm (US 7) double-pointed needles and Charcoal Grey, cast on 36(36:36:40:40) sts and work 3 rounds k2, p2 rib. Change to Natural White and knit 1 round. Cont with k2, p2 rib until the piece measures 7cm (2¾in). Change to 6mm (US 10) double-pointed needles (cont in st st) and inc 8 sts evenly = 44(44:44:48:48) sts. Place a marker around the middle st under the sleeve (beginning of round), this st should be worked in purl at all times to keep track of the beginning and end of the round. Inc 1 st on each side of the marked st every 2cm (¾in) until there are 66(66:66:70:70) sts. Work chart until the sleeve measures 47cm (18½in) for women and 53cm (21in) for men (or desired length). Place 8(8:8:10:10) sts from under the sleeve on scrap yarn or a stitch holder (marked st and 4[4:4:5:5] sts on each side). Knit the other sleeve the same way.

RAGLAN DECREASE

Read the entire text before joining the Sleeves and the Body.

Knit the Sleeves onto same needle as the Body = 240(254:268:282:296) sts. Place a marker at each join (the st where the Sleeve meets the Body) = a total of 4 sts marked. The marked sts and the 2 sts on each side should always be knitted in Natural White (a total of 3 Natural White sts per join). NOTE! Always dec in Natural White. Knit 4(2:3:3:3) rounds and begin raglan dec.

Raglan: Dec on each side of the marked sts. On the right side of the marked st, dec to the left by knitting 2 sts together through the back loop. On the left side of the marked st, dec to the right by knitting 2 sts together. (Remember to dec with natural white.)

Repeat the dec every other round until you have 96(102:100:106:104) sts left on the needle. Work a round of Charcoal Grey and dec evenly across the round = 88(88:92:92:92) sts. Cont to Neck.

NECK
Change to 4.5mm (US 6) needle and with
Charcoal Grey, work k2, p2 rib for 20cm (8in).
Cast (bind) off loosely in rib.

ASSEMBLY
Weave in loose ends and knit (or sew) together
under the Sleeves. Place the sweater in a bucket
of water (max. 30°C [86°F]) and leave it there
until all the air is out of the sweater. Stretch into
shape and dry flat. It is very important that you
do not hang the sweater top dry, as this will make
it stretch.

Chart

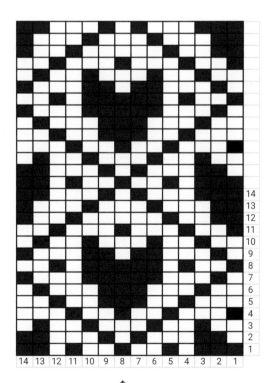

8 = Centre front on sweater. Count
from the middle where to begin
knitting on the chart.

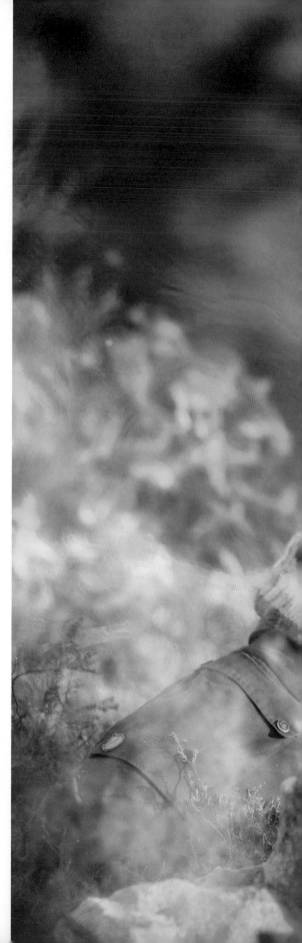

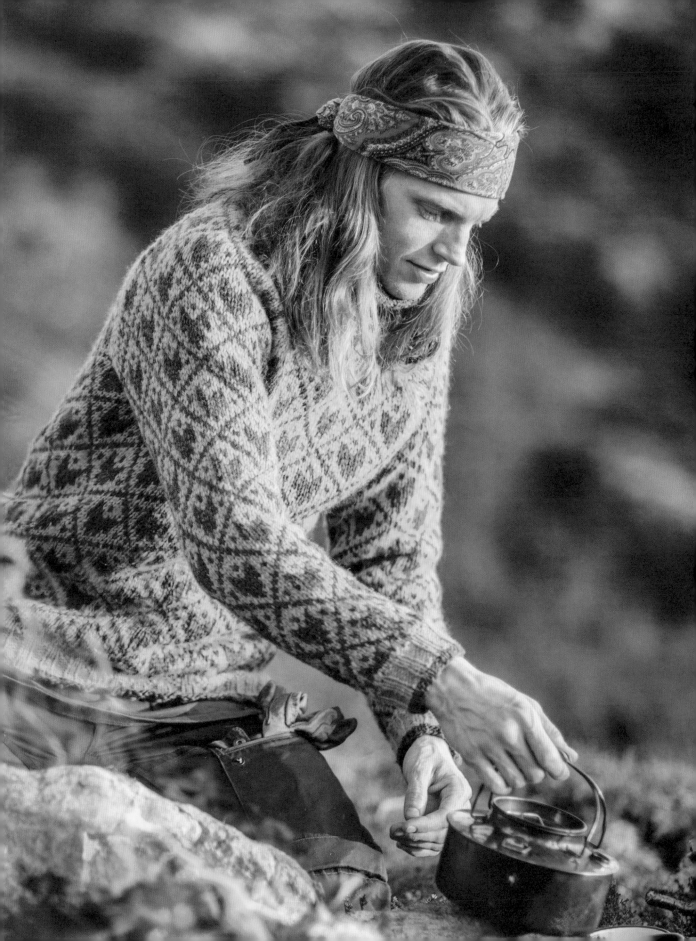

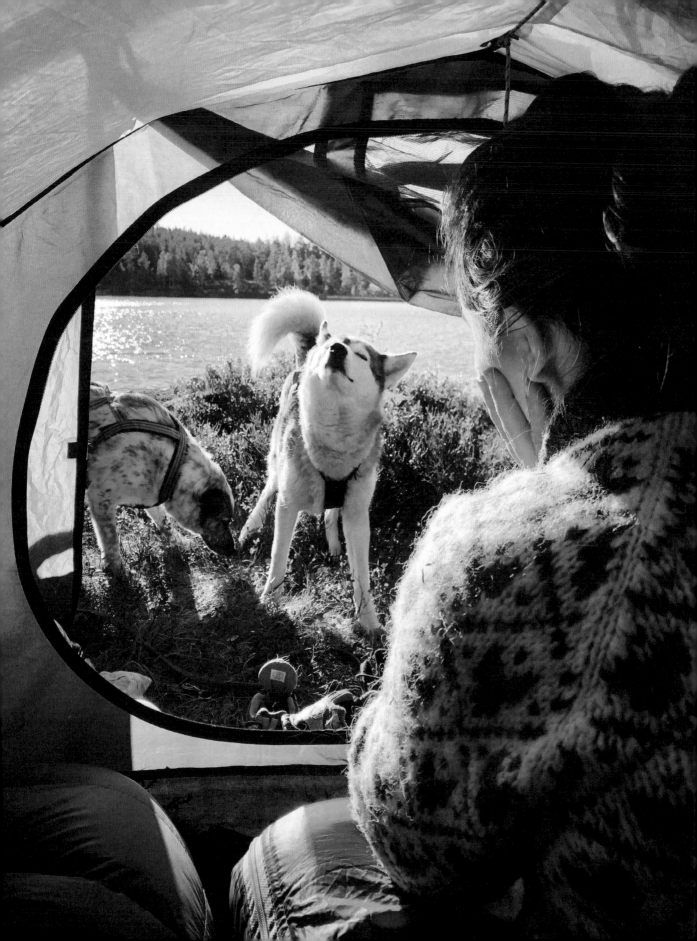

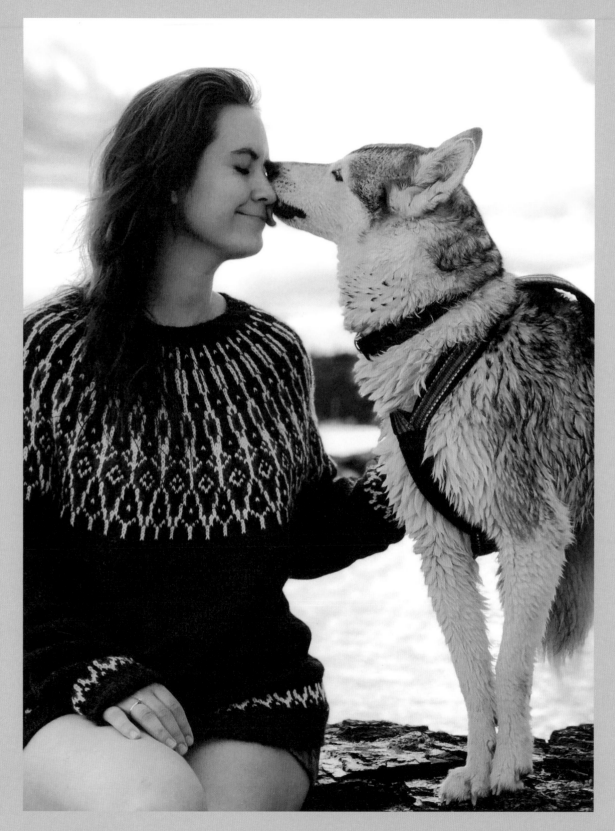

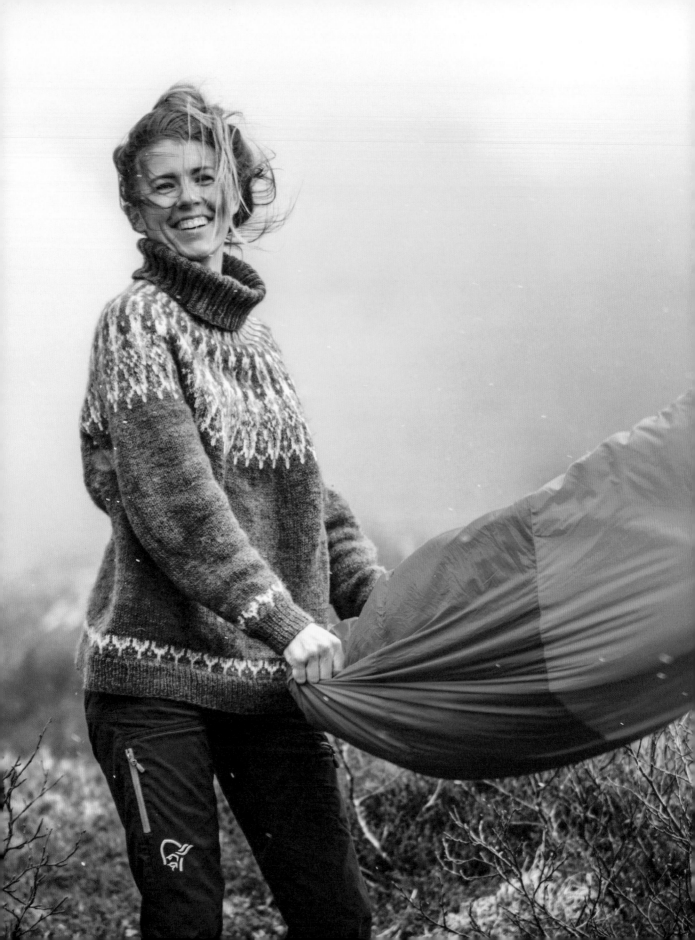

Tusseladd

Of all the sweaters I have designed, the Tusseladd sweater is the one closest to my heart. The sweater is named after the three-headed troll Tusseladd from the fairy tales I read as a child. The Tusseladd sweater is time consuming and a bit laborious to knit, but it's worth it: the result is a soft and fantastic sweater, or cardigan, if you prefer. It is extra nice to wear a garment that someone you love has knitted for you, and my own green Tusseladd sweater was knitted by my good friend, Caroline.

The Tusselad sweater is knitted in Tinde pelt yarn from Hillesvåg Ullvarefabrikk. The yarn is dyed on the sheep's natural grey colour, which gives the yarn a beautiful mottled and adventurous feel.

If you want a thicker variant, the Tusseladd Polar is right up your alley. The pattern is a bit simplified compared to the thinner version.

Tusseladd Sweater

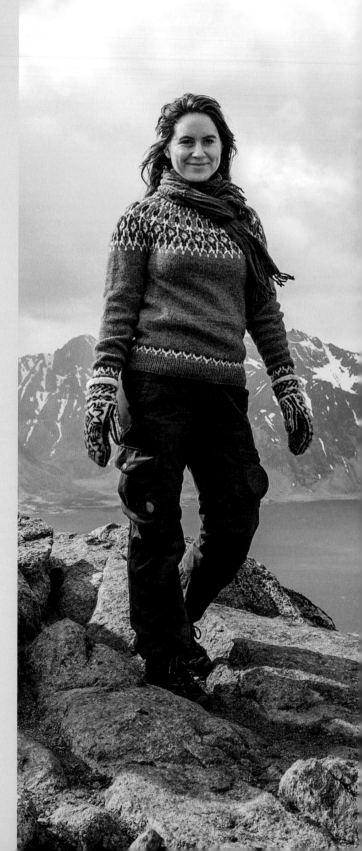

SIZES
S(M:L:XL:XXL)

TENSION (GAUGE)
10cm (4in) on 3.5mm (US 4) needle = 22 sts

YARN
Tinde from Hillesvåg Ullvarefabrikk. This yarn does not come in white, so use Sol from Hillesvåg.

AMOUNT OF YARN
Turquoise (652106) = 400(400:500:500:500)g (14[14:17½:17½:17½]oz)
Light Brown (652102) = 100g (3½oz)
Sol, Unbleached White (58400) = 100g (3½oz)

High neck:
100g (3½oz) extra of the base colour

KNITTING NEEDLES
3mm & 3.5mm (US 2/3 & 4) double-pointed needles
3mm & 3.5mm (US 2/3 & 4) 40cm (16in) circular needles
3mm & 3.5mm (US 2/3 & 4) 80cm (30in) circular needles

MEASUREMENTS
Sleeves women: 46(47:48:49:50)cm
(18¼[18½:19:19¼:19¾]in)
Sleeves men: 49(50:52:53:54)cm
(19¼[19¾:20½:21:21¼]in)
(or desired length)
Chest (unisex): 90(98:104:111:120)cm
(35½[38½:41:43¾:47¼]in)
Body length women: 38(40:42:43:44)cm
(15[15¾:16½:17:17¼]in)
Body length men: 43(44:45:46:47)cm
(17[17¼:17¾:18¼:18½]in)
(or desired length)

BODY

With 3mm (US 2/3) circular needle and Turquoise, cast on 198(216:228:246:264) sts. Work k1, p1 rib for 6cm (2¼in). Change to 3.5mm (US 4) circular needle (cont in st st) and work Chart A (if you knit tightly: go up one needle size when working charts). Place a marker at the beginning of the round and after 99(108:114:123:132) sts = front and back piece. Cont in st st in the round until the piece measures 38(40:42:43:44)cm (15[15¾:16½:17:17¼]in) for women or 43(44:45:46:47)cm (17[17¼:17¾:18¼:18½]in) for men (or desired length). Place 11 sts from each side of the sweater on scrap yarn or a stitch holder (the marked st and 5 sts on each side).
Set the work aside and knit Sleeves.

SLEEVES

With 3mm (US 2/3) double-pointed needles and Turquoise, cast on 42(48:48:54:54) sts and work k1, p1 rib for 6cm (2¼in). Change to 3.5mm (US 4) double-pointed needles (cont in st st in the round) and inc 6 sts evenly on first round = 48(54:54:60:60) sts. Work Chart A (change needle size if necessary). Cont in Turquoise. Place a marker around the middle st under the sleeve (the beginning of the round) and cast on 1 st on each side of this every 2cm (¾in) until there are 74(78:82:86:86) sts. Work until the piece measures 46(47:48:49:50)cm (18¼[18½:19:19¼:19¾]in) for women or 49(50:52:53:54)cm (19¼[19¾:20½:21:21¼]in) for men (or desired length). Place 11 sts from under the sleeve on scrap yarn or a stitch holder (the marked st and 5 sts on each side).
Knit the other sleeve the same way.

YOKE

Knit the Sleeves onto same needle as the Body = 302(328:348:374:392) sts. Place a marker at the first join. This marks the beginning and end of the round. Work Chart B (change needle size, if necessary) and dec as shown in chart.

NECK

Low neck: You should now have 120(132:140:148:156) sts on the needle. Knit 1 round in Turquoise and dec evenly to 120(120:124:124:128) sts. Change to 3mm (US 2/3) needle work k1, p1 rib for 3cm (1¼in). Cast (bind) off loosely.

High neck: You should now have 120(132:140:148:156) sts on the needle. Knit 1 round in Turquoise and dec evenly to 120(120:124:124:128) sts. Change to 3mm (US 2/3) needle and work k2, p2 rib for 20cm (8in). Cast (bind) off loosely.

ASSEMBLY

Weave in loose ends and knit (or sew) together under the Sleeves. Place the sweater in a bucket of water (max. 30°C [86°F]) and leave it there until all the air is out of the sweater. Stretch into shape and dry flat. It is very important that you do not hang the sweater to dry, as this will cause it to stretch.

Chart A

VV = Knit 2 stitches together (k2tog)
V = 1 stitch
M = stitch

Chart B (Yoke)

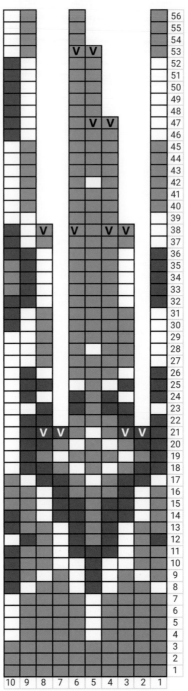

Row	Note
56	See Neck
53	Dec in Turquoise = 120(132:140:148:156) sts
51	Skip this round for sizes S, M, L
50	Skip this round for sizes S, M, L
47	Dec in Turquoise = 150(1615:175:185:195) sts
45	Skip this round for sizes S, M
44	Skip this round for size S
41	Skip this round for size S
38	Dec in Turquoise = 180(198:210:222:234) sts
21	Dec in Light Brown = 240(264:280:296:312) sts
2	Adjust to 300(330:350:370:390) sts
1	302(328:348:374:392) sts

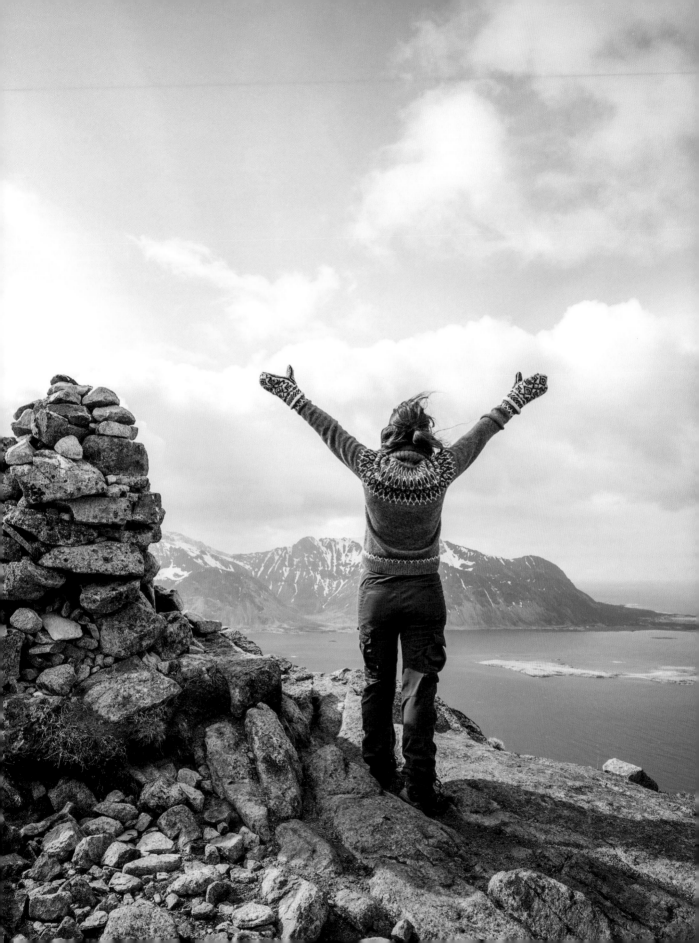

Tusseladd Polar

SIZES
S(M:L:XL:XXL)

TENSION (GAUGE)
10cm (4in) on 6mm (US 10) needle = 13 sts

YARN
Blåne pelt yarn and Troll from Hillesvåg Ullvarefabrikk. I use both Troll and Blåne because Blåne does not produce white yarn.

AMOUNT OF YARN
Blåne, Navy Blue (672133): 600(700:700:800:800)g (21¼[24½:24½:28¼:28¼]oz)
Blåne, Light Turquoise. (672130): 100g (3½oz)
Troll, Unbleached White (02702): 100(200:200:200:200)g (3½oz[7:7:7:7]oz)

KNITTING NEEDLES
4.5mm & 6mm (US 7 & 10) double-pointed needles
4.5mm & 6mm (US 7 & 10) 40cm (16in) circular needles
4.5mm & 6mm (US 7 & 10) 80cm (30in) circular needles

MEASUREMENTS
Sleeves women: 47(48:49:50:51)cm (18½[19:19¼:19¾:20]in)
Sleeves men: 50(51:52:53:54)cm (19¾[20:20½:21:21¼]in)
(or desired length)
Chest (unisex): 93(101:110:120:129)cm (36½[39¾:43¼:47¼:50¾]in)
Body length women: 41(42:43:44:45)cm (16¼[16½:17:17¼:17¾]in)
Body length men: 43(44:45:46:47)cm (17[17¼:17¾:18¼:18½]in)

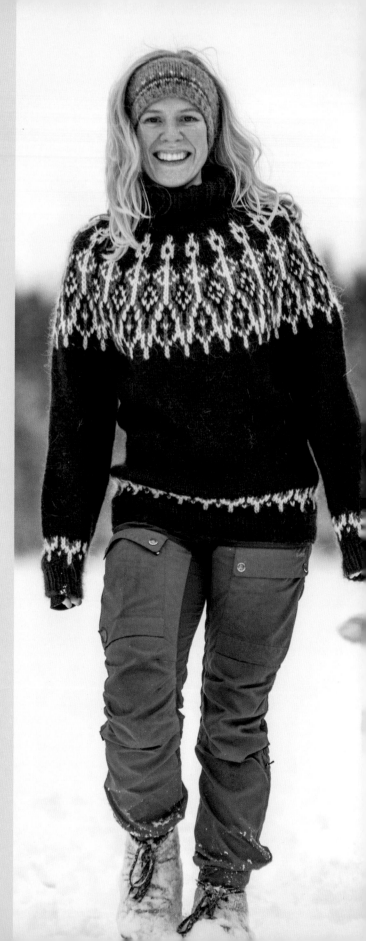

BODY

With 4.5mm (US 7) needle and Navy Blue, cast on 120(132:144:156:168) sts and work k1, p1 rib for 7cm (2¾in). Change to 6mm (US 10) circular needle (cont in st st in the round). Place a marker at the beginning of the round. Work Chart A (if you knit tightly: go up a needle size when working charts). Cont in Navy Blue until the piece measures 41(42:43:44:45)cm (16¼[16½:17:17¼:17¾]in) for women and 43(44:45:46:47) cm (17[17¼:17¾:18¼:18½]in) for men.

Place a marker at the beginning of the round and after 60(66:72:78:84) sts = front and back piece. Place 6(7:9:12:13) sts from each side on scrap yarn or a stitch holder. Set the work aside and knit Sleeves.

SLEEVES

With 4.5mm (US 7) double-pointed needles and Navy Blue, cast on 34(36:38:42:42) sts and work k1, p1 rib for 7cm (2¾in). Change to 6mm (US 10) double-pointed needles (cont in st st) and inc 2(6:4:6:6) sts evenly on the first round = 36(42:42:48:48) sts. Work Chart A (change needle size, if necessary) and cont in Navy Blue. Place a marker around the middle st under the sleeve and inc 1 st on each side of the marked st every 7 rounds until there are 52(54:56:60:62) sts. Work until the sleeve measures 47(48:49:50:51)cm (18½[19:19¼:19¾:20]in) for women and 50(51:52:53:54)cm (19¾[20:20½:21:21¼]in) for men.

Place 6(8:9:11:13) sts from the middle of the sleeve on scrap yarn or a stitch holder. Knit the other sleeve the same way.

YOKE

Knit the Sleeves onto the same needle as the Body = 200(210:220:230:240) sts. Place a marker at the first join. This marks the beginning and end of the round. Work Chart B for the yoke (change needle size if necessary) and dec as shown in the chart.

NECK

After adjusting the number of sts as shown in the chart, change to 4.5mm (US 6) needle and work k2, p2 rib for 20cm (8in). Cast (bind) off loosely.

ASSEMBLY

Weave in loose ends and knit (or sew) together under the Sleeves. Place the sweater in a bucket of water (max. 30°C [86°F]) and leave it there until all the air is out of the sweater. Stretch into shape and dry flat. It is very important that you do not hang the sweater to dry, as this will make it stretch.

Chart A

Chart B (Yoke)

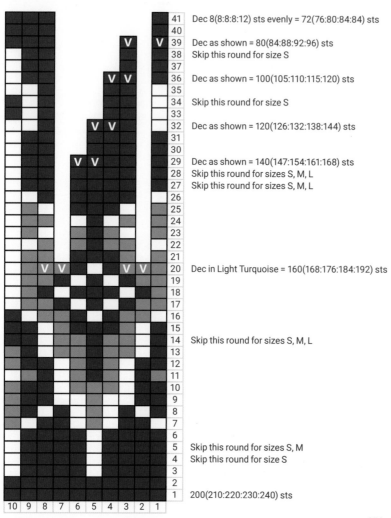

41 Dec 8(8:8:8:12) sts evenly = 72(76:80:84:84) sts
40
39 Dec as shown = 80(84:88:92:96) sts
38 Skip this round for size S
37
36 Dec as shown = 100(105:110:115:120) sts
35
34 Skip this round for size S
33
32 Dec as shown = 120(126:132:138:144) sts
31
30
29 Dec as shown = 140(147:154:161:168) sts
28 Skip this round for sizes S, M, L
27 Skip this round for sizes S, M, L
26
25
24
23
22
21
20 Dec in Light Turquoise = 160(168:176:184:192) sts
19
18
17
16
15
14 Skip this round for sizes S, M, L
13
12
11
10
9
8
7
6
5 Skip this round for sizes S, M
4 Skip this round for size S
3
2
1 200(210:220:230:240) sts

VV = Knit 2 stitches together (k2tog)
V = 1 stitch
M = stitch

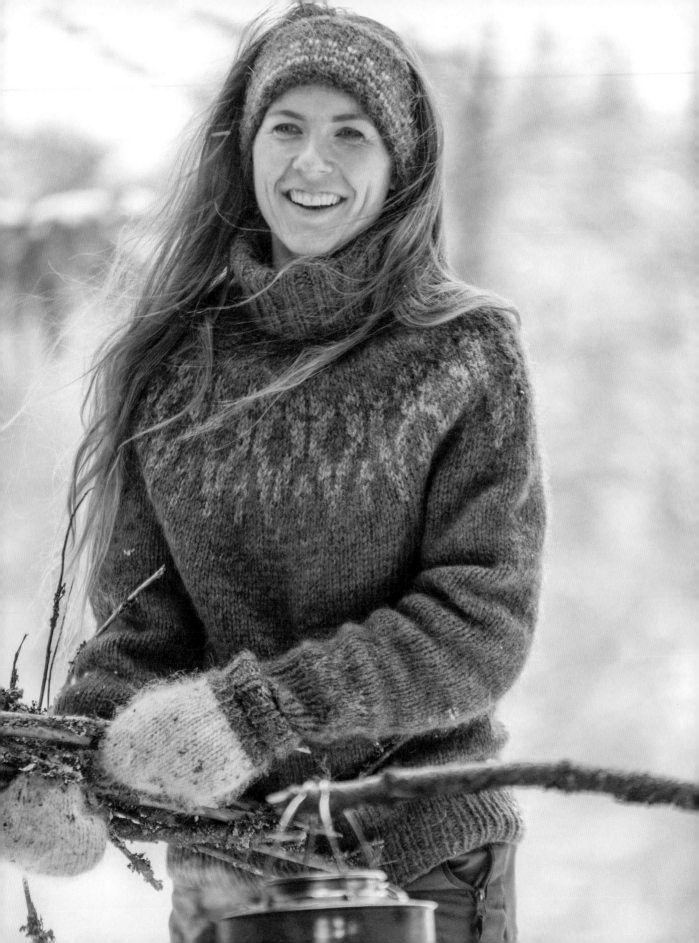

Tusseladd Cardigan

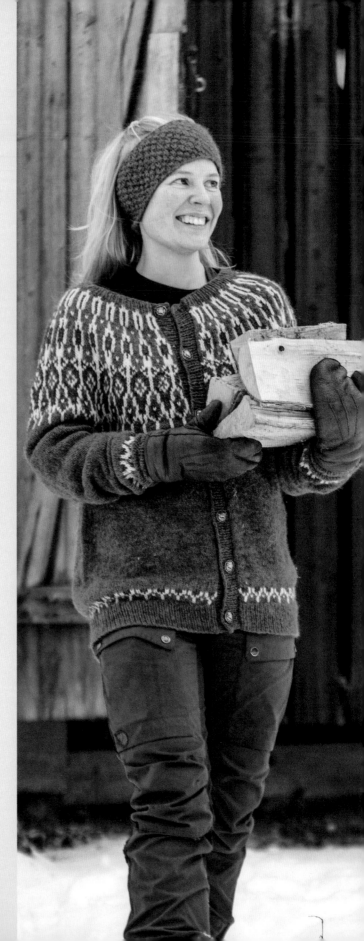

SIZES
S(M:L:XL:XXL)

TENSION (GAUGE)
10cm (4in) on 3.5mm (US 4) needle = 22 sts

YARN
Tinde pelt yarn from Hillesvåg Ullvarefabrikk
Tinde pelt yarn is not produced in white, use Sol lambswool from Hillesvåg.

AMOUNT OF YARN
Tinde, Turquoise (652106): 500(500:500:600:600)g
(17½[17½:17½:21¼:21¼]oz)
Tinde, Light Brown (652102): 100g (3½oz)
Sol, Unbleached White (58400): 100g (3½oz)

BUTTONS
7(7:8:8:8) 22mm (1in) tin buttons

KNITTING NEEDLES
3mm & 3.5mm (US 2/3 & 4) double-pointed needles
3mm & 3.5mm (US 2/3 & 4) 40cm (16in) circular
needles
3mm & 3.5mm (US 2/3 & 4) 80cm (30in) circular
needles

MEASUREMENTS
Sleeves women: 46(47:48:49:50)cm
(18¼[18½:19:19¼:19¾]in)
Sleeves men: 49(50:52:53:54)cm
(19¼[19¾:20½:21:21¼]in)
 (or desired length)
Chest (unisex): 93(101:107:114:123)cm
(36½[39¾:42¼:45:48½]in)
Body length women: 38(40:42:43:44)cm
(15[15¾:16½:17:17¼]in)
Body length men: 43(44:45:46:47)cm
(17[17¼:17¾:18¼:18¾]in)
(or desired length)

BODY

With 3mm (US 2/3) circular needle and Turquoise, cast on 199(217:229:247:265) sts. Work k1, p1 rib back and forth for 6cm (2¼in). The first row is the wrong side, so purl the first st (it is important that the outer sts are knit sts for picking up Button Bands later). When rib is complete, cast on 5 sts on right needle for steek stitches to be worked in purl at all times (these are not included in the stitch count). Change to 3.5mm (US 4) circular needle (cont in st st in the round). Knit Chart A (if you knit tightly: go up one needle size when working charts). The pattern is worked over 6 sts as shown in the chart + 1 st so that the pattern is symmetrical on both sides of the Button Bands (this also applies to the Yoke). Cont in st st in the round until the piece measures 38(40:42:43:44)cm (15[15¾:16½:17:17¼]in) for women or 43(44:45:46:47) cm (17[17¼:17¾:18¼:18¾]in) for men. Place markers on each side so there are 49(54:57:62:66) sts for each front piece and 101(109:115:123:133) sts for the back piece. Place 11 sts from each side of the cardigan on scrap yarn or a stitch holder (the marked st and 5 sts on each side).
Set the work aside and knit Sleeves.

SLEEVES

With 3mm (US 2/3) double-pointed needles and Turquoise, cast on 42(48:48:54:54) sts. Work k1, p1 rib for 6cm (2¼in). Change to 3.5mm (US 4) double-pointed needles (cont in st st) and inc 6 sts evenly = 48(54:54:60:60) sts. Work Chart A (change needle size if necessary). Cont in Turquoise. Place marker around the middle st under the sleeve (the beginning of the round) and inc 1 st on each side of this every 2cm (¾in) until there are 74(78:82:86:86) sts. Work until the piece measures 46(47:48:49:50)cm (18¼[18½:19:19¼:19¾]in) for women or 49(50:52:53:54)cm (19¼[19¾:20½:21:21¼] in) for men. Place 11 sts from under the sleeve on scrap yarn or a stitch holder (the marked st and 5 sts on each side).
Knit the other sleeve the same way.

YOKE

Knit the Sleeves onto the same needle as the Body = 303(329:349:375:393) sts. Work Chart B (change needle size if necessary) and dec as shown.

NECK

Finish off for where specified for size. You should now have 121(133:141:149:157) sts on the needle. Work 1 round in Turquoise and dec evenly to 121(121:125:125:129) sts. Cast (bind) off the steek stitches and change to 3mm (US 2/3) needle. Work k1, p1 rib back and forth for 3cm (1¼in) and cast (bind) off.

ASSEMBLY

Weave in loose ends and knit (or sew) together under the Sleeves. Sew two machine seams along the edges of the steek stitches. Sew three times to make sure the seams hold and nothing unravels. Cut between the two seams and knit Button Bands.

Right Button Band: With 3mm (US 2/3) needle and Turquoise, pick up sts along right front piece. *Pick up 3 sts, skip 1 st,* rep from * to * to end. The number of sts must be divisable by 2 + 1 so that both the first and last are knit sts. Work k1, p1 rib for 3cm (1¼in). Cast (bind) off in rib.

Left Button Band: Work as the Right Button Band, but with 7(7:8:8:8) buttonholes evenly spaced after 1.5cm (½in). Place the lowest buttonhole approximately 2cm (¾in) from the edge and the top approximately 1cm (½in) from the edge. Work 1.5cm (½in) and cast (bind) off in rib.

Buttonholes: Cast (bind) off 2 sts, which you cast on again on the next row.

Facing: Pick up sts on the wrong side of the Button Band (the first sts in the first row). Work 5 rows st st back and forth and sew the facing over the raw edge. Alternatively, sew a ribbon over the raw edge.

Place the cardigan in a bucket of cold water (max. 30°C [86°F]) and leave it there until all the air is out of the cardigan. Stretch into shape and dry flat. It is very important that you do not hang the cardigan to dry or it will stretch.

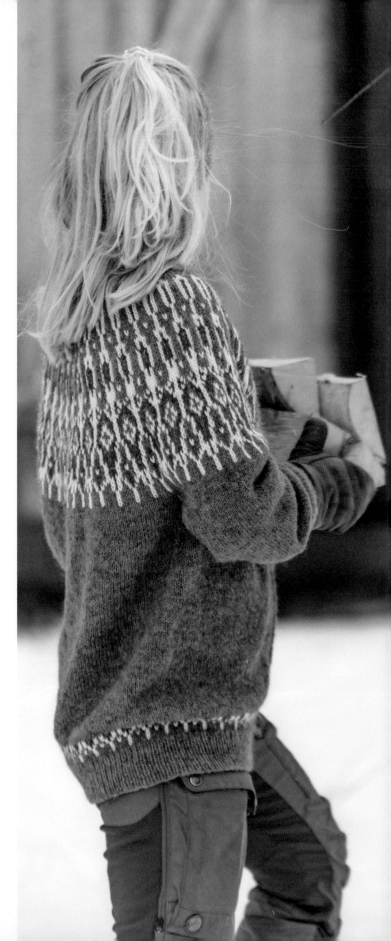

Chart A

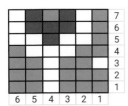

VV = Knit 2 stitches together (k2tog)
V = 1 stitch
M = stitch

Chart B (Yoke)

Row	Note
56	See Neck
53	Dec in Turquoise =121(133:141:149:157) sts
51	Skip this round for sizes S, M, L
50	Skip this round for sizes S, M, L
47	Dec in Turquoise = 151(166:176:186:196) sts
45	Skip this round for sizes S, M
44	Skip this round for size S
41	Skip this round for size S
38	Dec in Turquoise = 181(199:211:223:235) sts
21	Dec in Light Brown = 241(265:281:297:313) sts
2	Adjust to 301(331:351:371:391) sts
1	303(329:349:375:393) sts

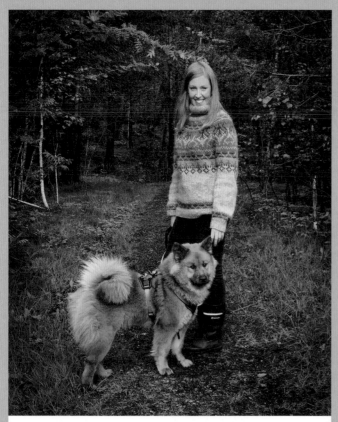

Bodil Dorothea Gilje / Tour Girl of the Year 2017

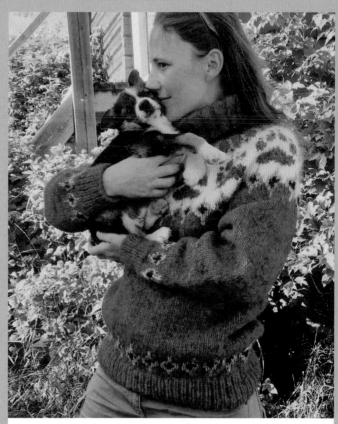

Vinterdans, Marit Beate Kasin / Dog Sledder

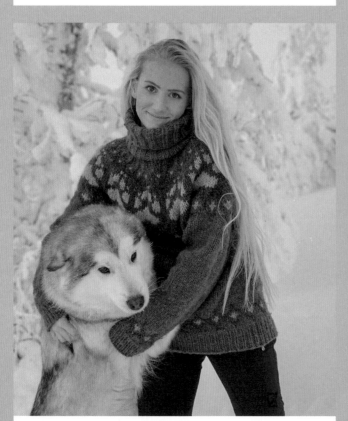

Tonje Blomseth / Adventurer

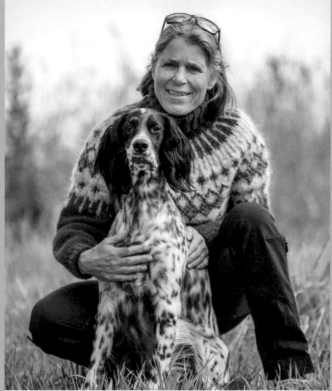

Sirikit Lockert & Føyka / Publisher and hunter

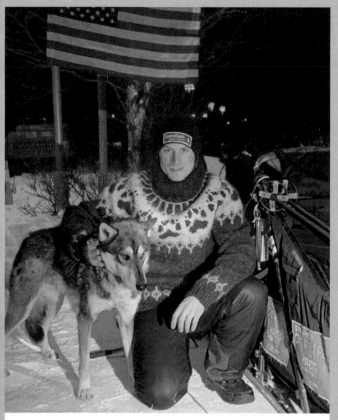

Dallas Seavey / Dog Sledder, Finnmarksløpet

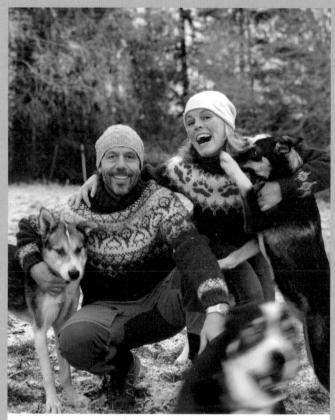

Nina Skramstad and Didrik Sand / Dog Sledders

Moa Hundseid / Adventurer, Mount Everest

Åste Innleggen / Norge på langs

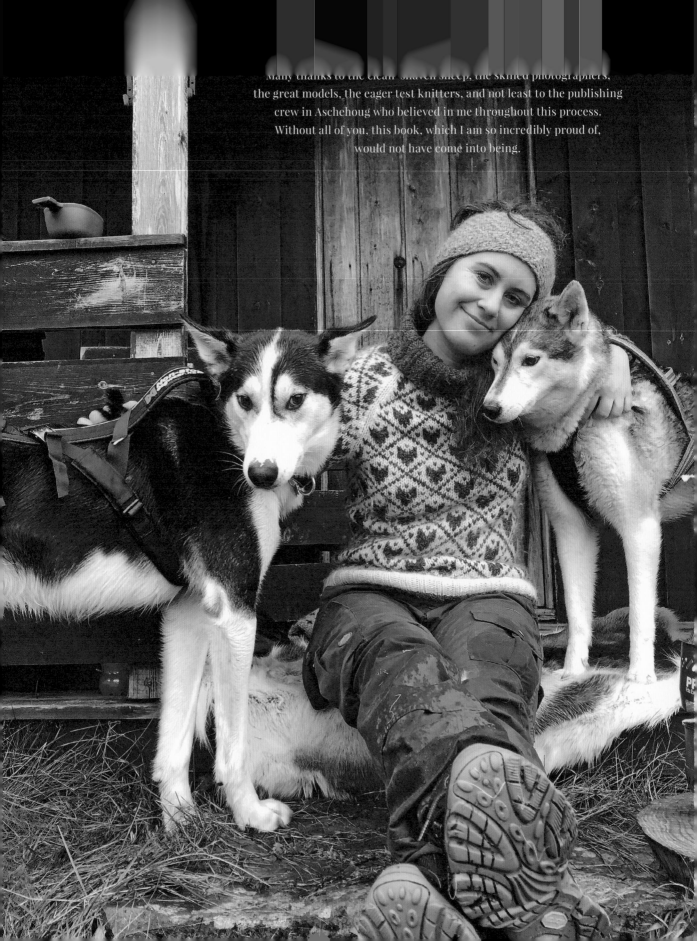

Many thanks to the clean-shaven sheep, the skilled photographers, the great models, the eager test knitters, and not least to the publishing crew in Aschehoug who believed in me throughout this process. Without all of you, this book, which I am so incredibly proud of, would not have come into being.